Don Harrison's Top Watercolour Techniques

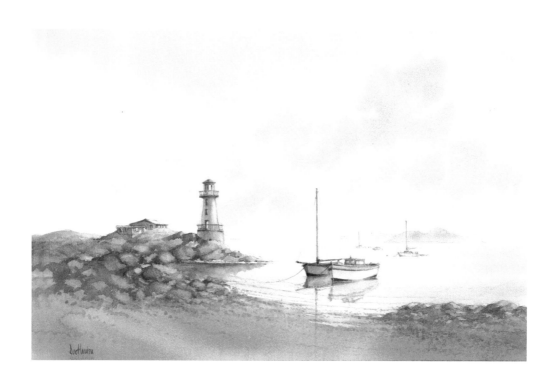

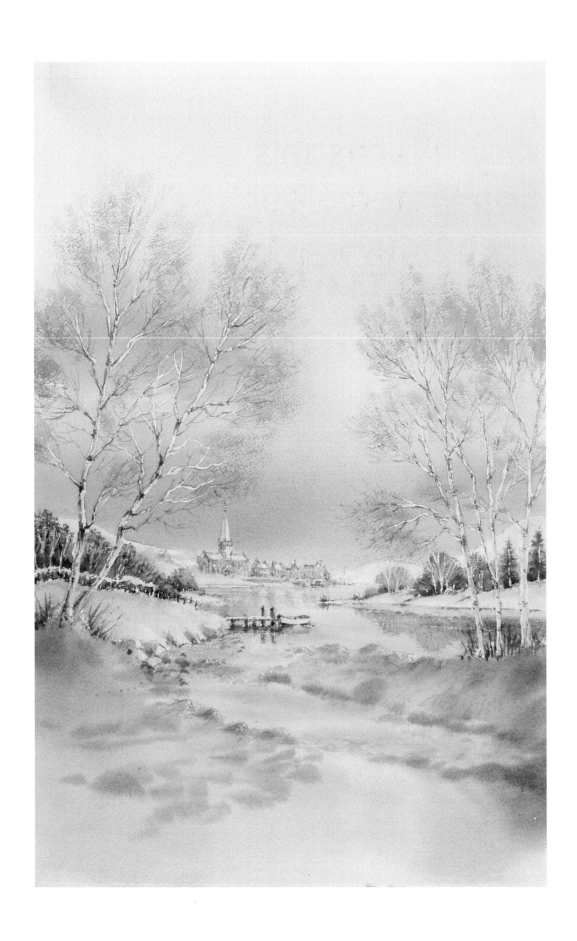

Don Harrison's Top Watercolour Techniques

WARRINGTON BOROUGH COUNCIL	
Bertrams	
751.422	£14.99

Collins

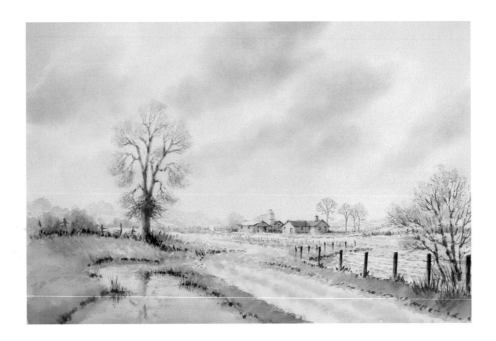

First published in 2005 by
Collins, an imprint of
HarperCollins*Publishers*
77-85 Fulham Palace Road
Hammersmith, London W6 8JB

The Collins website address is:
www.collins.co.uk

Collins is a registered trademark of
HarperCollins Publishers Limited.

09 08 07 06 05
5 4 3 2 1

**A catalogue record for this book is available from
the British Library**

Editor: Geraldine Christy
Designer: Penny Dawes

ISBN 0 00 718395 X

Colour reproduction by Colourscan, Singapore
Printed and bound by Printing Express Ltd, Hong Kong

Acknowledgements

This is now my fourth book with HarperCollins
and I would like to thank the in-house editorial
staff for their sterling efforts, as well as those
of freelance editor Geraldine Christy.

My long-suffering wife Sally has endured
many weeks of torture during the creation of
each book and deserves special mention.
Thanks also to friend Lionel Foreman for his
photos of the Cornish cove on p.24.

Finally, thank you to all the amateur painters
who have supported me at workshops and
exhibitions and have been kind enough to
purchase my previous books.

PAGE 1: **The Lighthouse** 36 x 55 cm (14 x 21 ½ in)
PAGE 2: **Icy Morning** 55 x 38 cm (21 ½ x 15 in)
PAGE 4: **Road to the Farm** 36 x 53 cm (14 x 21 in)
PAGE 5: **Evening Calm** 38 x 55 cm (15 x 21 ½ in)

Contents

Introduction 6

Coastal Scenes 8

Country Views 32

Buildings and Townscapes 44

Lakes, Rivers and Bridges 64

Further information 94

Index 96

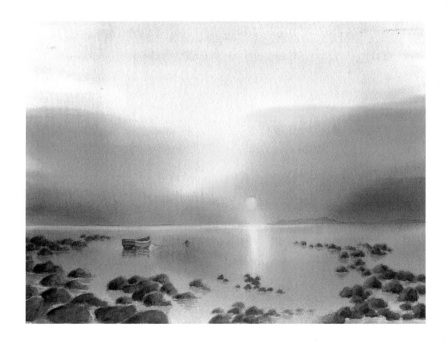

Introduction

Once you have acquired a basic facility in using watercolour paints you will be keen to tackle a complete painting. Sadly, it is at this point that many potential masterpieces end up relegated to the bin because of lack of planning, poor technique and incorrect timing. A vast number of instruction books and videos offer solutions, but they also present conflicting ideas, so deciding on the best approach can be quite a problem.

This book aims to help redress the balance by explaining key techniques for you, presented in a series of painting projects that cover a variety of subjects. Each project starts with a helpful reference photograph, followed by an explanation of the way to plan and then paint the scene. In each case the emphasis is on the key technique you require. Many other techniques are also shown and the book covers most of the important elements you need to consider.

A useful approach

My own method of painting is to work from light to dark, top to bottom, background to foreground. I work wet-in-wet in the early stages for the sky and background areas (and sea and rivers, where appropriate), then build up the land masses layer by layer. I tend to use pale, cool colours for the background, then warmer, stronger colours for the foreground. I also prefer to control how the paint behaves when applied to the paper rather than relying on so-called 'happy accidents' – in my experience these seldom occur and are usually the result of poor technique. Good planning, sound methods and a patient approach to each painting bring their own rewards and, for me, that is exciting enough!

Try to use good quality paper – the thicker, the better – as it is usually more durable and allows the water and paint to dry at a more consistent rate. I like to use Saunders Waterford 625 gm (300 lb) or Bockingford Extra Rough 425 gm (200 lb). These two robust papers do not need to be stretched. Use four spring retaining clips to hold the paper (especially if it is thin). If you use masking tape, do not tape all the way round as the sheet will ridge when the paper expands.

▲ Don painting on location.

Painting in watercolour should be both rewarding and enjoyable, so do not approach it too seriously. Practice is always helpful, so why not try some of the scenes in this book, working from the same reference photos that I used?

A few words about colour

In this book colours are described in a way that reflects their appearance – that is, as being either warm or cool. By 'cool', we mean the bluish, greenish colours that look cool, and by 'warm' those warmer-looking colours that lean towards red. Most times the description is obvious – for instance, a lemon yellow is cool looking, especially compared to other yellows such as, for example, the cadmium ones, which have a richer, warmer appearance.

I use a warm and a cool version of each of the primary colours (red, yellow and blue – which

cannot be mixed from other colours) and refer to them by a name that matches their look – cool yellow, warm yellow, cool red, warm red, cool blue and warm blue.

You probably have different manufacturers' colours with various names. To assess these, simply paint a little of each colour on a piece of white paper and decide whether the colour is warm or cool in appearance. You may have two or three warm blues (such as Ultramarine) and a couple of cool ones (for instance, Coeruleum or Cobalt Blue). You may have cool reds, such as Alizarin Crimson or Rose Madder. Manufacturers give their colours distinctive names to help you identify them from their huge range, but I think it is simpler to refer to primaries as warm or cool.

My own colour palette is circular and I position two reds, two yellows and two blues in pairs, equidistant around the edge – one a cool colour and the other warm. I add two further colours – the earth colours Raw Sienna and Burnt Sienna, which have names almost universally used.

▲ My colour selection (with typical comparable colours shown in brackets – in this case from Daler-Rowney) has cool yellow (Lemon Yellow), warm yellow (Cadmium Yellow Deep), Raw Sienna, warm red (Cadmium Red), cool red (Alizarin Crimson), Burnt Sienna, warm blue (French Ultramarine), cool blue (Cobalt Blue or Coeruleum).

It is worth buying artists' quality rather than students' paints as they contain more pigment. I prefer to use tube paint rather than pans because it is easy to squeeze out the amount you require and simpler to pick up a good brushful of colour.

▼ **Mooring Time** 36 x 53 cm (14 x 21 in)

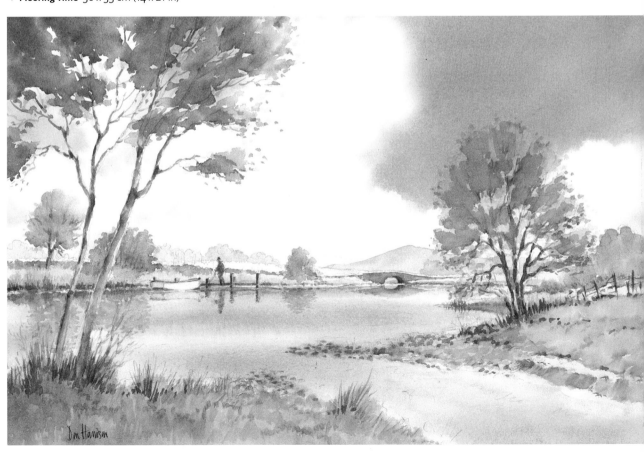

Lulworth Cove 37 x 55 cm (14½ x 21½ in)

Coastal Scenes

Painting light-reflecting mud banks

Most painters produce muddy colours easily, so it may seem odd to read about techniques for painting mud banks! But, with care, you can avoid using dull, lifeless mud colours in your pictures.

Planning the painting

I wanted to create an atmospheric painting from a scene photographed on a dull overcast day. I chose the top view because the mooring lines lead towards the focal point. The grassy bank in the other photograph tends to create a barrier across the scene.

A rough pencil sketch was useful to rearrange the various elements to improve the composition. I enlarged the sky area and varied the size and shape of the grassy banks. The line of the mooring ropes and the meandering water left by the tide guide the viewer's eye to the line of boats. I rearranged the boats to provide better balance, and the masts and their reflections provide vertical features of varied length. I intended to paint the distant trees and banks pale, then use much stronger colours for the foreground area of grasses.

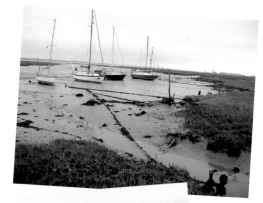

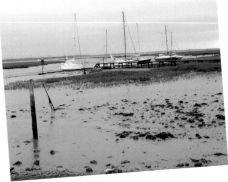

▲ Two views of moored yachts at low tide in Ashlett Creek, Southampton Water.

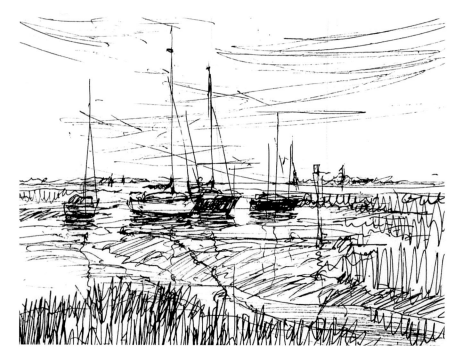

- Graduate the sky dark to light, then the water light to dark.

- Paint distant trees lighter to suggest depth.

- Rearrange the boats to improve the composition.

- Rivulet of water left by tide leads the eye to the yachts.

- Three main grassy banks are varied in shape and size to provide balance.

- Use stronger, brighter colours for foreground grass.

Top technique

The secret in creating mud banks that reflect the sky and appear to be damp is to build the colour in layers. Each time a new layer is overpainted wet-in-wet, the previous layer must be almost dry to avoid picking up colour and leaving a light patch instead of strengthening it. It is essential to avoid adding weak, wet paint to 'too wet' paint on the paper surface or adding it to existing watery colour on the palette before applying.

If you are working with thin paper, after each large wash lift the retaining clips in turn, pull the paper taut and allow it to dry before applying the next layer of colour.

Here, the initial underwash on damp paper shines through subsequent layers and helps the mud banks to stand out from the water.

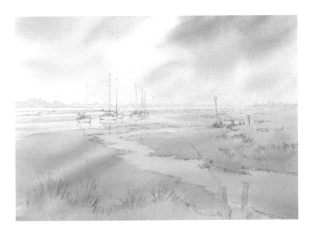

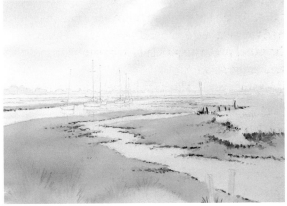

▲ Damp the paper and apply an underwash of cool yellow and Raw Sienna over the main land masses. When dry, damp the paper again and paint the sky, sea and mud banks using the same warm blue colour. Paint the water using horizontal brushstrokes, taking the colour all over the mud banks, but keeping it a little lighter in these areas.

▲ Paint a light mixture of cool yellow and Raw Sienna over the mud banks. When almost dry, blend a touch of warm red into the mixture and apply, using curving brushstrokes to match the slopes. Clean the palette, mix some warm red with cool blue and blend into the damp surface, leaving some lighter parts unpainted. Leave to dry, then re-damp the paper. Overpaint using warm blue with a little Burnt Sienna.

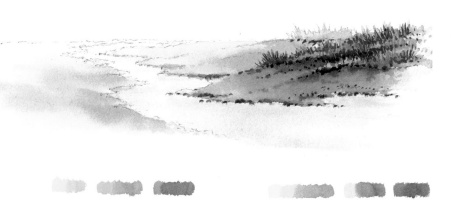

◄ Try this practice exercise. From the left, paint a cool yellow and Raw Sienna underwash, then blend in cool red and blue while it is still damp. Blend in cool blue and Burnt Sienna before the surface is dry. For the grasses overpaint cool yellow and blue with warm yellow and blue. Use warm blue and Burnt Sienna for detail on the grass and mud banks.

Other useful tips

Using a tonal sketch

A one-colour tonal sketch is always helpful for establishing the right balance between light and dark areas, and in deciding the strength of colour needed in each area of the finished painting. Use a strong dark colour for your sketch as this gives more tonal latitude.

For simplicity, paint three layers – light, medium and dark. Start with a light wash over the sky and sea areas. When this is dry, overpaint with darker colour. Before this dries, add stronger colour wet-in-wet where needed. Allow to dry, then add some really strong dark colour to paint the bolder areas and apply a few dark hints here and there.

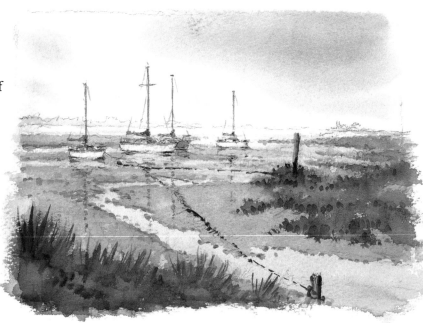

▲ After planning the composition make a one-colour sketch to show tonal values.

Simplifying rigging and ropes

Draw in rigging wires, but do not paint them as complete lines. Use a rigger to flick in the two ends of the wire and the viewer will 'see' them as connected. Remember, too, that the height of the mast from the waterline should equal the depth of the reflection from the waterline.

At all states of the tide boats react to the flow of the current (and the wind), so a row of moored boats all face the same way. Lines running through the centres of the boats where their hulls sit on the water should all lead to an imaginary vanishing point on the horizon. If this line is then extended forward of the prow, the painter will disappear into the water somewhere on this line and the reflection of the painter will come to the same spot on the water. The mooring buoy should also be placed on the same line.

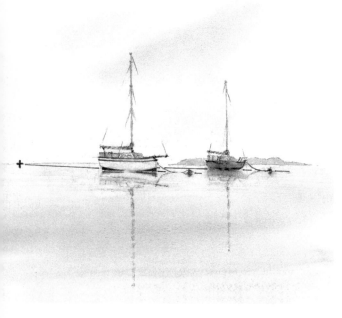

◀ Moored boats should all point the same way. Extend a line forwards from the prow at water level (shown in red). The mooring line drops in the water along this line, the buoy a little further along.

▶ In this detail note that the gaps between the single boat and the pair, and between the pair and the cluster of three, differ. No two masts are the same height and the colours are also varied. The overall effect is that they look a natural group. The one yacht leaning in is a bonus – if it leaned outwards it would take the eye out of the picture.

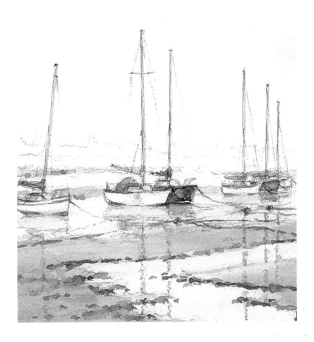

Finished painting

The sloping cloud shapes deliberately mirror the ragged band of water in the foreground. The curves on the mooring chains emphasize the slopes of the mud bank. The masts and their reflections, together with the pole on the right, are useful vertical features that offset the mainly horizontal areas in the middle distance and help to keep a viewer's eye within the painting.

Estuary 36 x 51 cm (14 x 20 in)

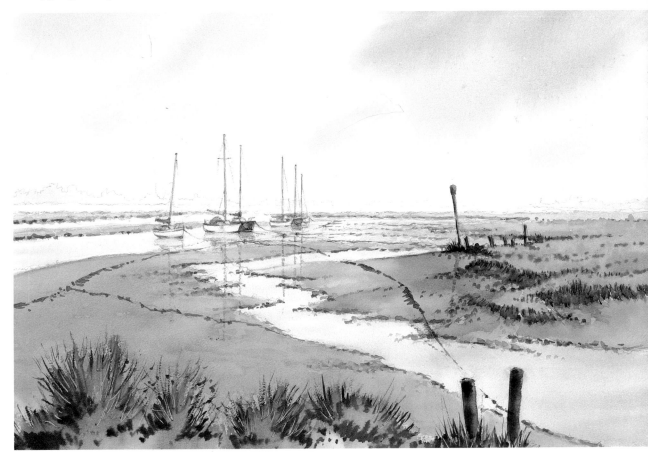

Suggesting movement on calm water

Ripples that occur on the surface of calm water when it is disturbed are transient, so painting them is not so simple – or is it? The key is timing, technique and practice.

Planning the painting

I wanted to enhance the simple composition of the photograph with the addition of a second boat and a figure, which would add a useful vertical feature. A person engaged in activity also adds interest and gives life to a picture.

Painting some circular ripples beneath the boats would convey the gentle movement of the water as the fisherman manoeuvred the two boats into position. I planned to 'play down' the distant banks and buildings to focus attention in the foreground and create depth. Also, by leaving a light area in the background around the figure, a viewer's eye would be drawn to this spot.

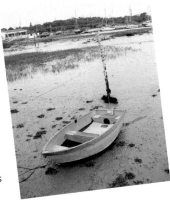

▶ Viewing and photographing the dinghy from above provided useful reference.

▼ I made a pencil sketch to plan the picture and its areas of light and dark.

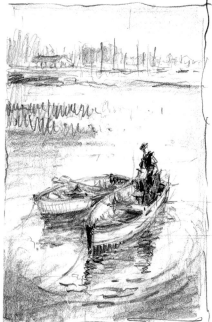

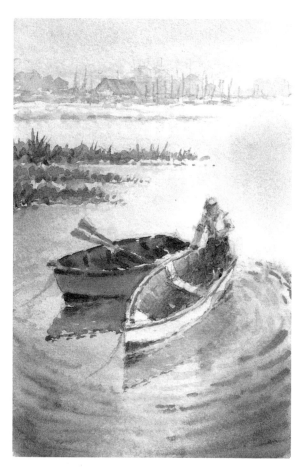

- Graduate the sky dark to light.

- Keep distant buildings pale in tone.

- Insert a figure to balance the composition.

- Paint circular ripples around the boats.

- Leave a light area behind the figure to attract the eye.

◀ This quick colour sketch matched the tonal variations of the pencil sketch. The light area behind the figure was extended down into the reflections for greater impact and to attract the eye.

Top technique

This exercise shows how easy it is to build up ripples in a logical sequence of steps. The light streak down the centre focuses attention on the main subject. Although the practice exercise illustrates fairly regular oval shapes, when you are working on a finished painting break up the regular nature of the ripples by leaving gaps here and there to give a more random appearance. Ensure that the nearer ripples are further apart and painted more boldly than those further back.

▶ Damp the paper, then apply a light wash of cool yellow and Raw Sienna. Leave a light streak down the centre or where you wish attention to be focused. When dry, damp the paper again. When the heavy shine fades apply cool blue each side of the light streak and allow to blend gently.

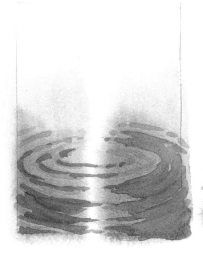

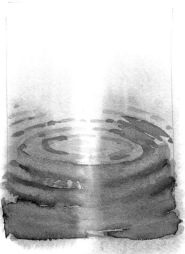

▲ Just before the paper dries out, use a stronger mixture of cool blue and a medium round brush to paint slightly broken ovals. Start with a small oval and work outwards, making larger shapes each time as if you had dropped a pebble onto the surface of a pond.

▲ Before the paint dries out, use a 'thirsty' (barely damp) brush to lift out some light areas here and there between the painted ovals to soften the overall effect.

▲ Just before the paint dries again, use warm blue to strengthen the broken oval shapes with the point of a round brush. Add this wet-in-wet first for soft edges. Then, as the surface dries out, apply wet-on-dry for crispness. Make nearer curves slightly thicker with wider gaps between them than those further away. Introduce other colours to suit your particular subject.

Other useful tips

☐ Avoiding problems with boat shapes

Many people have trouble working out the shape of boats and their reflections, particularly when looking down on them from a jetty or bank.

Here is a way to improve your painting of boats, by simply making a boat shape with a putty rubber and placing it on a mirror to check the shapes of the reflections.

▲ Take a soft putty rubber and roll it into a ball between your fingers or the palms of your hands, then continue to roll it into a cylindrical shape.

▲ Flatten one end by tapping it on the table. Then squeeze the sides at both ends gently to narrow them, squeezing the one away from the flat end harder to produce a sharp edge.

▲ Place the rubber on a flat surface and straighten up the sharp end when viewed from the side. Press the thumb down onto the top surface to flatten it. With a little more shaping you should have a fairly presentable boat shape.

▲ Place the boat-shaped rubber on a mirror and view from an appropriate high or low position to use for reference. It can be leaned over as if stranded on a beach or kept upright with a small piece of thread attached to the front to represent a mooring rope or painter.

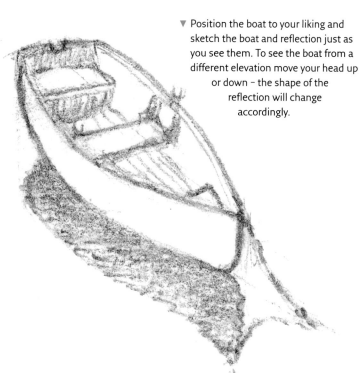

▼ Position the boat to your liking and sketch the boat and reflection just as you see them. To see the boat from a different elevation move your head up or down – the shape of the reflection will change accordingly.

Finished painting

The cool neutral shades of the background trees and buildings were faded gently into the misty sky to add atmosphere. These areas were painted wet-in-wet for soft edges. The bank in the mid distance is stronger, but still neutral, in colour to avoid distracting the eye from the focal point. Note how the light area highlights the figure.

Checking the Moorings 53 x 37 cm (21 x 14½ in)

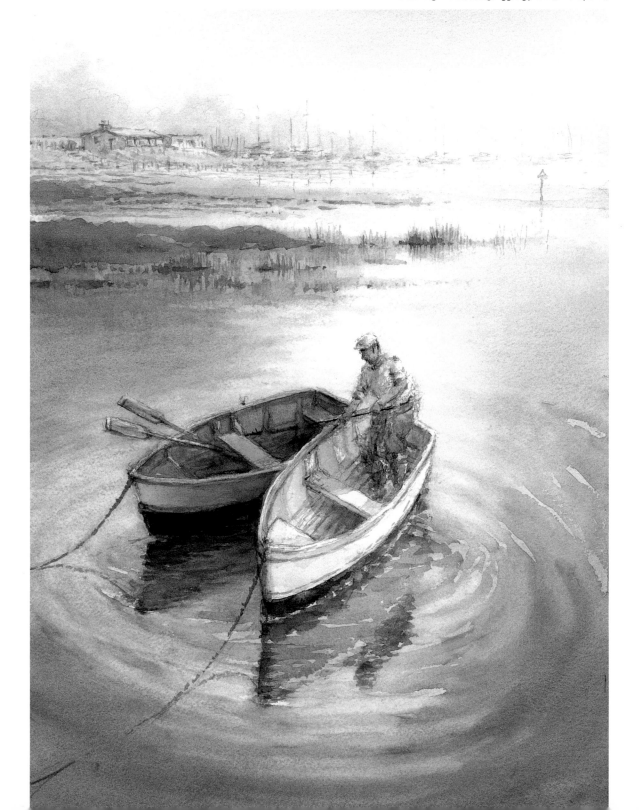

Painting realistic waves

Waves approach the shore in ragged rows and it is essential to keep their appearance random to avoid them looking too formal and unrealistic. Unpainted areas of paper can be left to represent the wave crests.

Planning the painting

To capture the movement of heavy swell and pounding waves on the rocks below this lighthouse I visited the location on a bright, but breezy, day. Painting on site would have been fun, but rather hazardous, so I settled for a quick sketch and a few photographs, and still managed to get drenched by spray!

The massive foreground rocks and crashing waves make a lively setting for the lighthouse, which is placed rather too centrally in the photograph and early sketches I made. Moving it a little to one side would improve the overall composition of the painting.

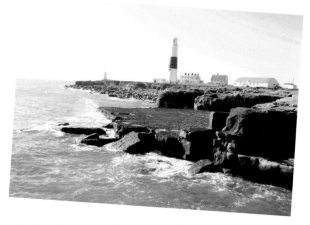

▲ Portland lighthouse, Dorset, warns of the rocky coastline.

To balance the huge bulk of rocks on the right, I showed part of the dark foreground rock in the left-hand corner.

In my colour sketch I painted the foreground rocks with stronger colours than the more distant ones to suggest depth. The sea area should match the sky, so I used pale tints of cool blue, blending in stronger colour here and there, and adding a hint of green close under the rocks. The distant buildings are kept pale for added depth.

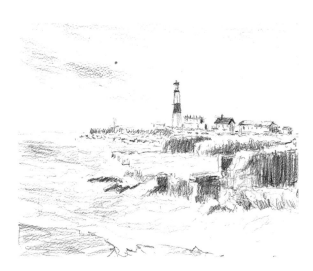

▲ The pencil sketch accentuates the dark shadows between the rocks and makes them look very solid.

▶ In this quick colour rough the white of the paper suggests both the clouds and the tops of the waves.

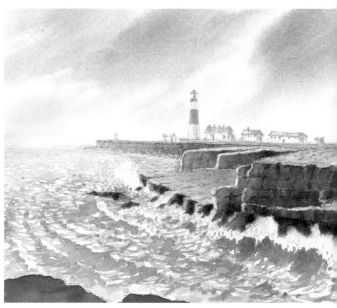

Top technique

Leave unpainted areas of paper to represent wave crests. Draw a few rows of ragged waves at an angle, then paint them using flowing brushstrokes and a medium round brush to simulate the flow of the water for the first layers. Then use the sides of the bristles with curved strokes to emphasize the darker wave troughs.

Build up the colour and accentuate the wave crests by adding stronger colour in the dips.

Make the foreground waves look a little greenish, especially when they are close to large rocky areas. Before the first layers dry, paint really strong colour just below the wave crests and allow it to blend into the shadowed areas below. Leave some of the paler colours showing through here and there for variation.

For this exercise the waves are in fairly orderly rows, but make them less regular in your finished painting – submerged land masses or rocks can disturb the orderly progress of waves.

▲ Draw a few rows of waves at an angle, then paint them with a light mixture of cool blue, leaving the wave tops as unpainted paper. Use a medium round brush with gentle, flowing brushstrokes to match the movement of the water.

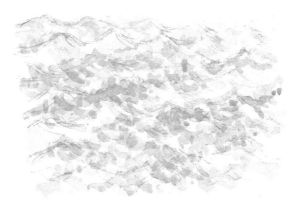

▲ Before this dries, blend in a little more of the same colour. Add a touch of stronger colour in the dips between the waves, then a little cool yellow in the foreground waves to make them greenish.

▶ When the paint is almost dry add warm blue to the mix to paint just below the wave crests and use the sides of the bristles and curved brushstrokes to pull the colour into the troughs between the waves. Darken the mixture with Burnt Sienna to create stronger shadows under the wave crests while still damp, blending into the other colours.

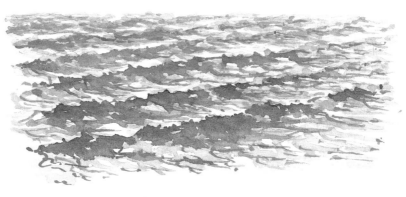

◀ Colours used here are cool and warm blue, then stronger mixes of the same colours plus Burnt Sienna. Adding cool yellow gives a green tint to the water in places.

Other useful tips

☐ Suggesting spray with unpainted paper

You can also leave areas of paper unpainted to suggest sea spray. Work wet-in-wet for soft edges, lifting out more colour at the edges with a piece of damp kitchen roll if required. Dark rocks can be painted with a strong fairly dry mixture of warm blue and Burnt Sienna. Pull the brush down to the edge of the spray and lift off the paper quickly to leave a rough edge at the bottom. When the paint is dry it is easy to pick out small white specks to suggest flecks of spray with a scalpel or small piece of sandpaper, but take care not to damage the surface of the paper. The more white paper, the more effective will be the result.

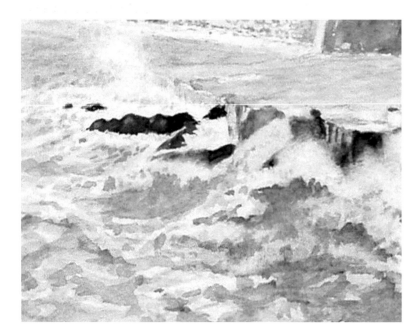

◀ To indicate spray where it strikes the rocks, leave unpainted areas of the paper. When working wet-in-wet this will be a soft edge. When lifting colour keep turning the piece of kitchen roll to avoid depositing paint back into the white areas.

☐ Putting waves in perspective

Waves approach the shore in succeeding 'rows', which means that the artist has to consider perspective when painting them. I have shown them approaching the shore in vaguely curved rows, but in reality they tend to be a little less evenly curved. Generally speaking, waves breaking onto a sandy shore form rollers as they approach land and then run up the beach or shingle at low level until they dissipate.

The important point is to increase the size of the waves and troughs the nearer they are to you. The distant sea is fairly flat and even the larger waves appear of modest size from afar. Nearer the shore, more detail can be shown and the colours made bolder. Paint the sky and sea one after the other to ensure the colours match.

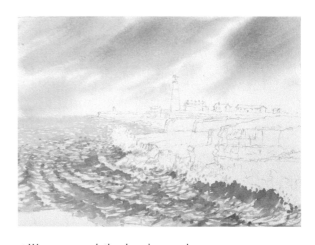

▲ Waves approach the shore in ragged rows, so perspective needs to be considered when painting. Waves and troughs increase in size the nearer they are to you.

◄ Large vertical fissures fill with shadows in strong sunlight. This detail shows how highlighting these brings out the shapes of the rocks.

Finished painting

The darker sky on the left is intended to balance the two rocky areas. Note the distant waves are pale and flat and the nearer ones stronger in colour and tone and more turbulent. The same variation in tone and colour is also evident in the rocky headlands. Distant ones are pale with no detail, mid distance a little darker. Nearer rocks are bold with flat, mainly vertical facets – use vertical strokes for these, and thin dark lines for random horizontal cracks. The buildings and lighthouse are painted light in tone to look distant.

Lighthouse at Portland, Dorset 33 x 37 cm (13 x 14 ½ in)

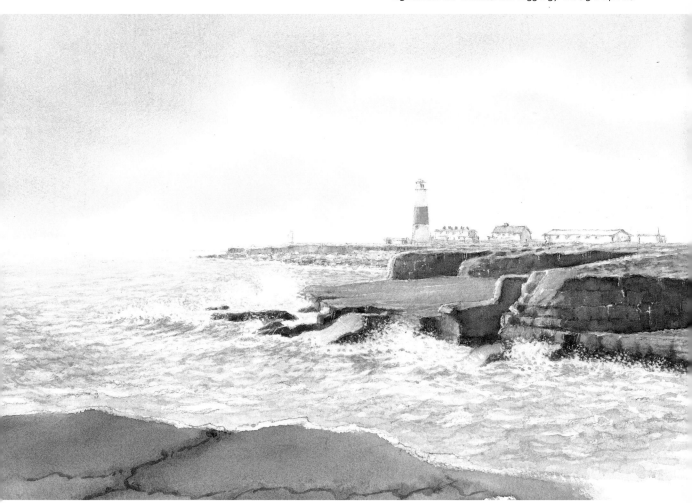

Masking out to create white highlights

One snag with leaving the paper unpainted for the waves is that it is impossible to paint over the area with long, sweeping wet-in-wet brushstrokes. Using masking fluid to reserve the white of the paper gives the artist far more freedom at the painting stage.

Planning the painting

Strong winds made it difficult to hold a camera still, let alone to sit and sketch or paint the ever-changing sea. Although exciting to watch, a large open expanse of sea can sometimes appear boring in a picture, so some imaginative treatment is needed to make a painting with impact.

For a moody, subtle effect, I decided to use a limited palette to produce strong neutral tints for the sea and sky to contrast with the white surf. In the colour sketch I simply left the paper unpainted for the wave crests, planning to use masking fluid in the finished painting to achieve crisp white tops to the waves.

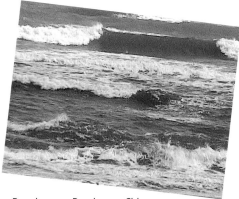
▲ Rough sea at Branksome Chine, Poole, Dorset.

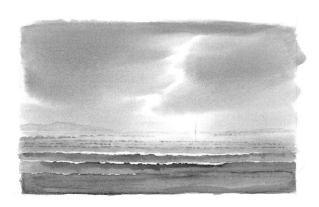

► In my colour sketch I lowered the horizon to make room for a bold sky and introduced a couple of distant headlands.

Top technique

Use masking fluid to protect the surface so that you can form ragged white horizontal strips to represent crisp-edged rolling wave crests. If you are applying it with a brush, soap the bristles first to protect them, or use a rubber-tipped applicator or professional applicator pen. Make the wave crests random in shape with thinner ones here and there in the background. A thin sliver on the horizon can also look effective. Ensure the painting is completely dry before gently removing the dried fluid to avoid damage to the paper; it is easier to do this if you are using smooth paper.

◄ Choose an applicator that suits the job in hand and clean thoroughly after use.

Other useful tips

☐ Using dark shadows to shape waves

To suggest the curve of rolling waves, brush clean water over the bottom of the waves, then paint a dark shadow below the white wave crests and allow it to blend gently down into the dampness. This produces a dark to light graduated wash under the crests, making the waves look curved and helping the white crests to stand out more. Make the paper damp, not sopping wet, or the blending will be hard to control.

▲ Painting dark graduated shadows below the wave crests adds realism.

☐ Using neutral colour mixes

For the crisp white wave edges and distant sailboat in the finished painting below I used masking fluid to protect the white of the paper.

These two versions of the same painting use alternative neutral colour schemes to achieve variation. In each an initial underwash of cool yellow and Raw Sienna was applied first.

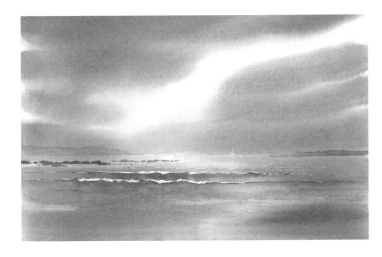

◀ Burnt Sienna was used to neutralize the cool and warm blue washes.

◀ Clouds and sea were painted first with cool blue on damp paper, then darkened with Burnt Sienna and warm blue. Colour was lifted out here and there to give soft-edged light areas. Thin ragged lines were added to show ripples in the shallow water. Masking fluid was removed when all was dry.

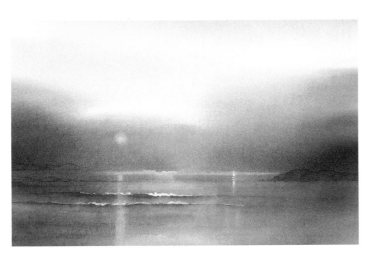

◀ Cool blue was used to dull down the warm red that was laid over the cool yellow and Raw Sienna underwash.

◀ Clouds and their reflections were painted over the dry underwash with warm red and, while still damp, more warm red and cool blue were pulled in from each side for heavier clouds. Stronger colour was applied just above and below the horizon with a large brush. When dry, headlands and shading below wave crests were painted with a stronger mix.

Painting rocky headlands

Rocky areas can be very complex, so it helps to build up colours in layers, then overpaint heavy shadows. The reflections in the sea below are best painted at the same time to retain a good colour match.

Planning the painting

Either of the views in my two reference photographs would make a very pleasant upright painting, but I decided to use elements from each to create a more panoramic view. My aim was to balance the bold shapes of the rocky headlands with a pair of moored boats. In my preliminary pencil sketch I added a second boat to help fill the open area in the centre, but the two boats were a little too close to the middle. I decided to overlap the two craft and move them slightly to one side, which improved the composition.

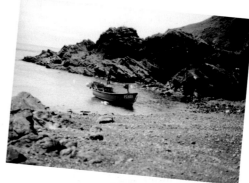

▶ Two views of the same bay in Cornwall provide useful reference.

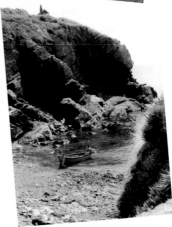

◀ Pencil sketches enabled me to plan a composition using features from both photographs.

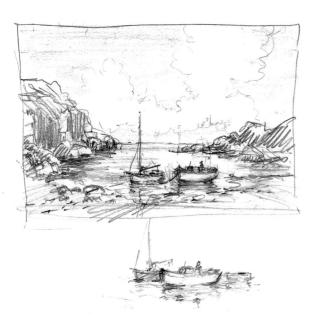

▼ In the colour study the two boats positioned close to the smaller headland help offset the rocky outcrop on the other side.

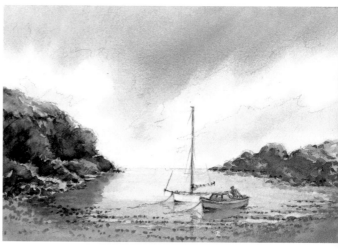

By making a colour study I could change the overcast weather in the photographs and settled on painting a bright sky with fluffy clouds to contrast with the bold rocky headlands. The large dark areas of curving rocks are varied in size and shape and make the composition look well balanced. Placing the boats even closer to the headland on the right balances the large rocky mass on the left of the picture.

Top technique

Rocky outcrops can look complex, so it is useful to draw them first in simple outline. You can then add shading to work out the light and dark areas before attempting to paint them. Your pencil sketch showing these tonal differences will be a useful guide at the painting stage.

The exercise below shows that painting a rocky headland is similar to creating tone with pencil. Build the colours up in layers and overpaint dark shadows. Paint the reflections below the headland at the same time to retain a good colour match. It is important to remember that when blending into damp paper, a stronger mixture can be used – if the paint is too weak and watery, back-runs may occur.

▲ Before painting a complex headland make a small outline pencil sketch. Use a soft pencil to draw just the main shapes, omitting any detail.

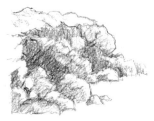

▲ Add light shading first, then heavier shadow, building up into a three-dimensional effect. Make sure the direction of light is consistent and, for contrast, leave a few light edges on the side it is coming from.

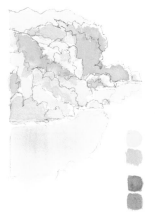

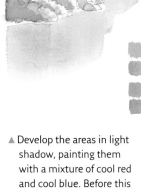

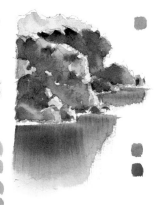

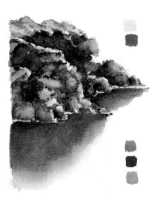

▲ Damp the paper, then paint a light wash of cool yellow and Raw Sienna over the headland and reflections. Just before this dries, blend in a pale mixture of warm and cool red, placing this mostly in the shaded areas.

▲ Develop the areas in light shadow, painting them with a mixture of cool red and cool blue. Before this dries, blend in a mix of warm red and cool blue in places. Paint the grassy area at the top of the headland with cool yellow.

▲ Blend a touch of cool blue into the grassy area. Paint Burnt Sienna over the dark shadow areas and, before this dries, blend in warm blue. Paint the reflections using the same colours.

▲ Overpaint a mixture of warm yellow and warm blue on the grassy bank. Add heavier shading on the headland with a strong mixture of Burnt Sienna and warm blue. When all is dry, overpaint a pale wash of cool blue in places for extra shading, leaving highlights on the edges of some of the rocks.

Other useful tips

☐ Making fluffy white clouds look real

Sometimes clouds that should be light and fluffy can look rather heavy. The key is to leave the clouds unpainted except for a light underwash and paint the sky colour around them wet-in-wet to leave soft edges. To remove excess sky colour, use a small, barely damp piece of kitchen roll to push sky colour clear of cloud areas, lifting at the same time. Turn the kitchen roll often to avoid depositing unwanted paint.

▲ Draw cloud shapes, then wet the entire sky area. When just damp, paint the clouds with a very pale mixture of Raw Sienna and cool yellow. (The colour is shown darker here to demonstrate.)

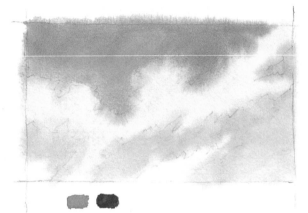

◀ When dry, damp the whole area again and paint blue sky around the cloud shapes with a mixture of cool and warm blue.

☐ Adding interest to an empty seashore

Foregrounds should be interesting to the viewer, but not distract from the focus of the painting. Adding seaweed, a few pebbles or rock to a plain sandy beach, for instance, can improve its appearance and add to the overall composition.

Paint the sand itself first, using a large brush. Then, when this is almost dry, paint the rough horizontal streaks of dark seaweed at the edge of the shore. Use either the tips of the bristles on a well-worn hake to do this, or a small round brush or squirrel brush laid on its side.

▲ Paint the sand using a mixture of cool yellow and Raw Sienna and, before it dries, blend in a touch of cool red. When almost dry again, blend in a strong mixture of warm red and cool blue.

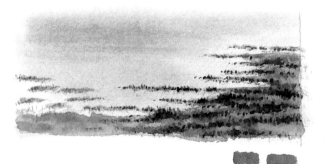

▲ Paint the streaks of weed with a strong mixture of Burnt Sienna and warm blue when the surface is almost dry. Darken the mix with more warm blue and introduce a few vertical spiky ends with a fine brush.

▶ In this detail the dark weed patches in the shallow water and along the edge of the beach were dabbed in using a large hake and a dry mixture of warm blue and Burnt Sienna. With the brush held fairly upright, the flat edge of the bristles tends to curl upwards as the tips are pressed onto the paper and, used with care, produce ragged-topped clumps of weeds.

Finished painting

A bright, light, low cloud mass in the sky contrasts well with the bold, colourful headlands and makes them look even stronger. The sweep of the heavily seaweeded foreground ties the two sides of the painting together, avoiding either headland looking remote. Adding the seaweed to the water as well as to the shore adds a naturalistic look to the image. The lack of ripples on the water adds to the calm and tranquillity.

Secluded Bay 36 x 53 cm (14 ½ x 21 in)

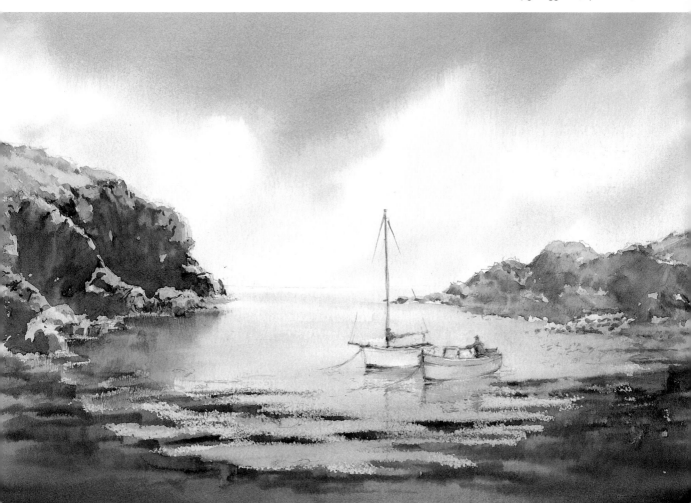

Using blending to capture evening light

For sunsets, as in most seascapes, it is always sensible to paint the sky and sea at the same time so that the colours are harmonious. Wet-in-wet, or wet blending, is ideal for this, but its timing is all-important.

Planning the painting

The object here was to re-create the calmness of a beautiful tranquil summer evening by painting a sunset-tinged sky that reflected the same colours on the flat water below. Very little needed changing in the atmospheric photograph I used for reference. In fact, the sun was just out of the picture, but the colours of the sky and water make the view memorable. The rocks were virtually in silhouette and I needed to rearrange them a little to improve the composition of the painting. In particular, the heavy dark area at the bottom of the photograph needed to be reduced to avoid it overpowering the scene.

It was dark soon after the photograph was taken, so I completed a quick pencil sketch back in the studio. This enabled me to start planning a more balanced picture. I enlarged the moored dinghy and added a few directional wisps of cloud.

▲ The setting sun casts a warm glow over the nearby rocks and headland.

▼ The rocky area at the front was reduced and rearranged for better compositional balance in my pencil sketch. A few wispy clouds were inserted in the sky.

Top technique

Wet-in-wet technique, also known as wet blending, depends to a great extent on correct timing. Check the degree of dampness of the paper surface frequently, looking at it from the side with the light behind it. The strength of the paint is also important – you need to avoid too much water in both the paint mix and the brush. Perhaps the method could more properly be described as 'damp-in-damp'.

Once the paper has been brushed over with an initial wash of water, a stiff paint mixture is required for subsequent blending; otherwise, excess water can cause large unwanted back-runs. By simply damping the paper all over before blending in colour, you can achieve soft edges in the early stages of the painting. When it is dry, create features such as rocks or a boat that need crisp-edged shapes using wet-on-dry paint.

Here, three simple steps were required to achieve the background for my painting. Try a similar exercise for yourself.

▲ Damp the paper all over. When the heavy shine has subsided, apply a graduated mix of cool yellow and Raw Sienna from light to dark on the sky area and dark to light from the horizon down. Before this dries blend a touch of warm red into the area above and below the horizon to suggest light clouds.

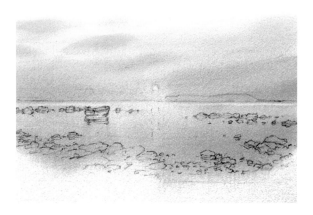

▲ Damp the paper all over again, then strengthen the clouds and their reflections with more warm red. Use a large hake or squirrel mop brush and curved brushstrokes.

▲ Just before the paint is dry, but while the paper is still damp, add cool blue to the mixture, but no more water. Blend the colour in using curved, sweeping brush movements across the sky and horizontal ones across the water. Leave a clear sliver unpainted on the horizon to separate the sea from the sky.

Other useful tips

☐ Painting small boat reflections

Drawing a dinghy freehand can sometimes be difficult. A way of helping you draw a boat and its reflections is to construct box-shaped guidelines. Try this with a simple dinghy viewed from the side. Because the curved sides of the boat bulge outwards they hide most of the dark coloured anti-fouling that is applied to the bottom of most boats. From this viewpoint all that can be seen of this are two lateral 'V' shaped areas fore and aft just above the waterline. This area is also in shadow, so the boat colour and its reflection will merge together.

For soft-edged reflections paint wet-in-wet and for clearly defined ones work wet-on-dry. Make sure you align the reflection vertically below the boat itself.

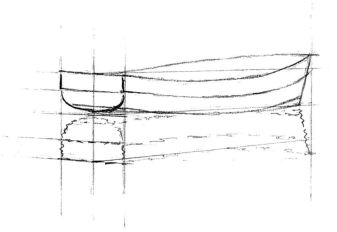

▲ Use a rectangular box (or brick) shape as a guide to make it easier to draw the outline of the boat. Note that the front and rear of the boat tend to curve upwards. The back should be a symmetrical shape.

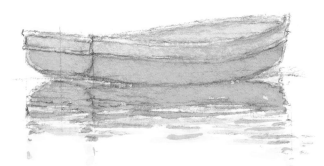

◄ Paint the boat and reflections with a pale mix of cool yellow and Raw Sienna. Use short horizontal strokes to suggest ripples where the reflections end. When dry, overpaint the lower hull with a mix of Raw Sienna and warm red.

► Paint the two lateral 'V' shaped areas and their reflections with a mix of Burnt Sienna and warm blue. Overpaint the boat and its reflection with a light mix of Raw Sienna and warm red, then add Burnt Sienna to make a stronger colour and apply this to the lower part of the boat and its reflection. Add more warm blue for a really dark mix to paint the thin shadows under the beading and top edge of the boat. Finally, paint a pale blue wash over the interior and back that is in shadow.

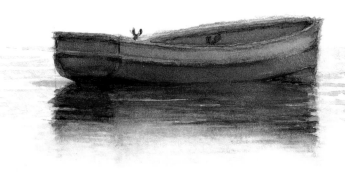

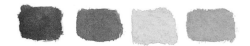

▶ In this detail you can see that the half round rock shapes are fairly flat at the base where they sit on the water. Although virtually in silhouette, each rock has a light patch on the side that is nearest the sun. The reflection below is lighter in tone and painted with a ragged edge.

Finished painting

A little more colour has been introduced into the finished painting than was evident in the original photograph, but the overall feel of calmness and tranquillity of the scene has been maintained. The large bulk of the foreground rocks has been reduced and partly replaced by the cluster of small rocks, creating some variation. Both the rocks and the cloud shapes direct the eye towards the focal point – the boat.

Southern Sunset 23 x 34 cm (9 x 13 ½ in)

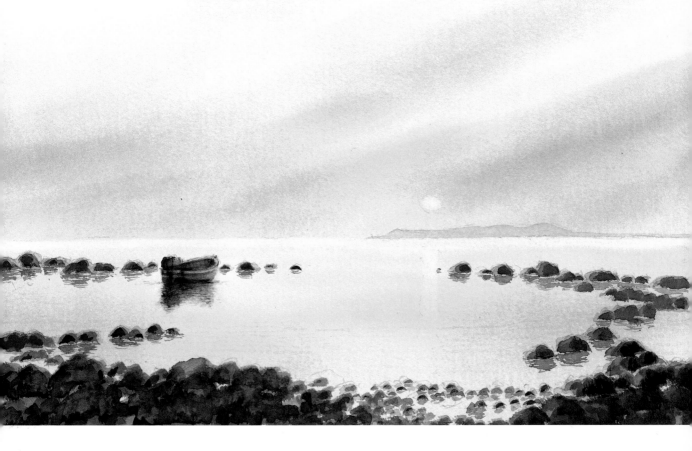

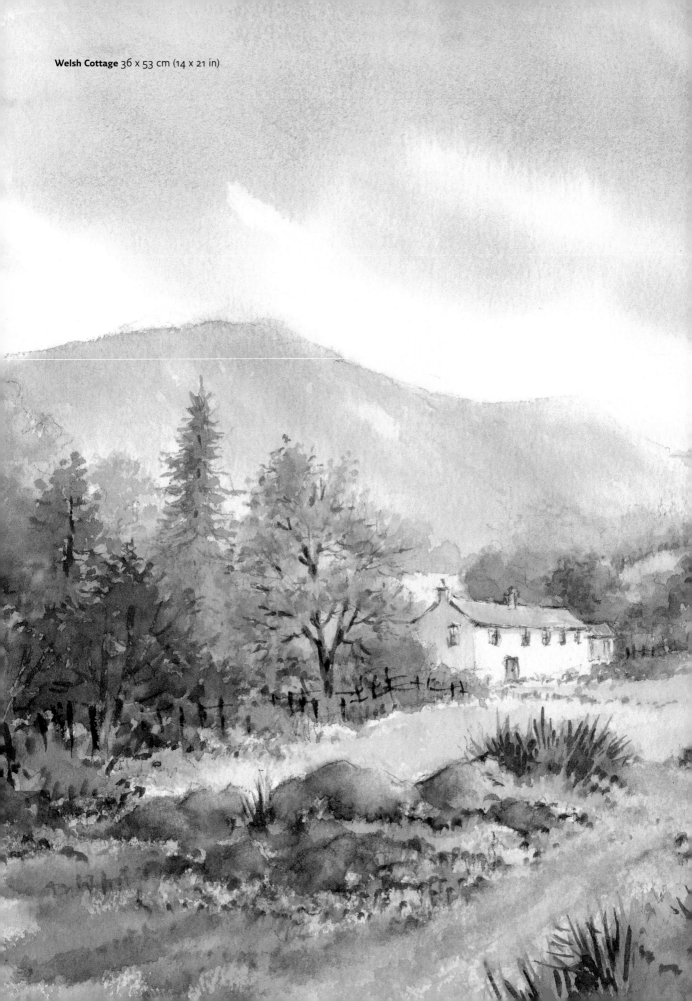

Welsh Cottage 36 x 53 cm (14 x 21 in)

Country Views

Painting snow-covered mountains

Painting snow on mountains is more accurately described by what is not painted rather than what is since, for the most part, the gleaming white snow may be suggested by unpainted paper. In contrast, a combination of pale and dark shadows can be used to bring out contours and crevices.

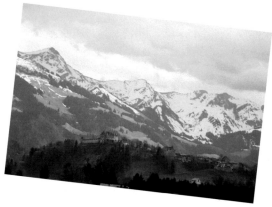

▲ A view of Swiss mountains offers various options for a painting.

Planning the painting

The reference I used for this painting was a quick photograph of a view across the mountains taken while travelling through Switzerland. The distant chateau or castle was probably a famous local landmark and stood out proudly on the distant hillside. Although the detail of its architecture is far from clear, the building adds a useful focal point to the scene.

I was unsure whether to opt for a portrait or landscape format for this painting and tried many variations before reaching my decision. In my rough colour study I intended to balance the large bulk of the large mountain on the left with just a few darker foreground trees, but they took attention away from the large building on the hill. So, I adjusted the foreground in the finished painting to give a more balanced composition.

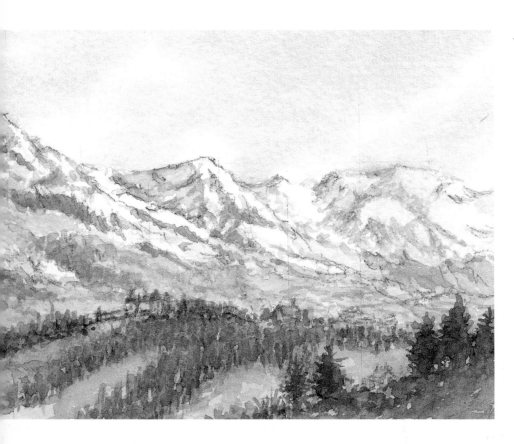

◄ In this colour study the mountain range is deliberately painted a little paler as it recedes into the distance.

Top technique

Suggest white snow by leaving areas of unpainted paper, adding a variety of tones to denote contours and edges in mountains and snowy hillsides. Make nearer mountains taller and vary their shapes, too, making sure that they do not simply have points at their tops. Do a pencil sketch first as a guide, with shading to suggest diagonal shadows on the snowy sides that are away from the sun.

Paint shadow areas first, using a small round brush with ragged diagonal brushstrokes. While still damp, blend in more colour in places for variation. Blend in darker shadows wet-in-wet, but do not make them too dark.

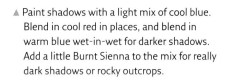

▲ Paint shadows with a light mix of cool blue. Blend in cool red in places, and blend in warm blue wet-in-wet for darker shadows. Add a little Burnt Sienna to the mix for really dark shadows or rocky outcrops.

Finished painting

On the whole, a cool look has been maintained despite the warmer bands of foreground trees. The fields in the valley are pale in tone and the mountains are less prominent as they recede into the distance, which all adds to the feeling of depth. Ample white space represents the snow-covered slopes that are not in shadow.

Distant Mountains 29 x 32 cm (11½ x 12½ in)

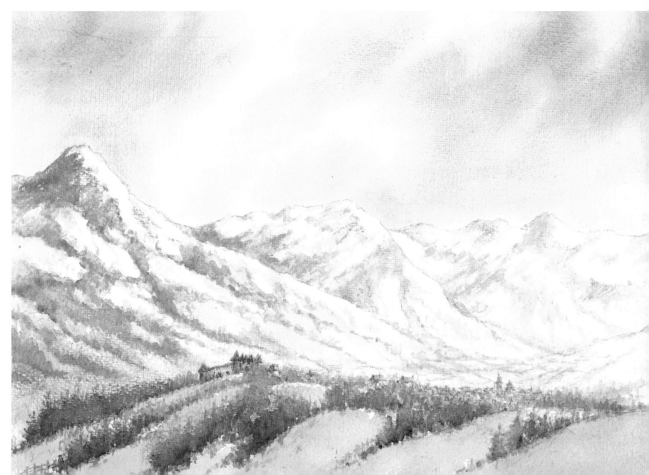

Painting realistic grapes

It is very tempting to draw grapes as a series of flat oval shapes, but this method does not produce a realistic-looking result. The fruit shapes should overlap and the colour within each needs to be graduated to convey its 'bloom'. A single highlight on each grape will make it appear rounded.

Planning the painting

Walking alongside a vineyard on a warm autumn evening I spotted a single bunch of grapes surrounded by leaves of all colours. The nearby village was a hazy blur on the horizon, with a cluster of light green trees on a distant hill. Here was an ideal opportunity for a painting.

▲ Last grapes on the vine, with Nézignan l'Evêque in the distance.

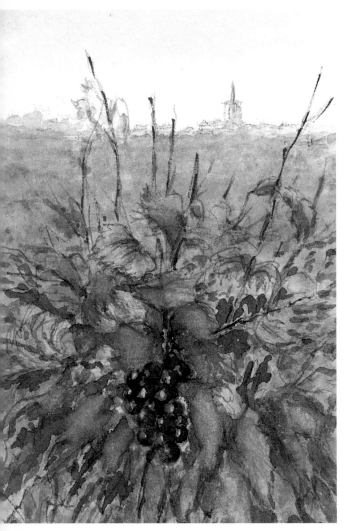

I decided on an upright version of the scene, focusing on the foreground, but I also wanted to include the distant trees as vague shapes to suggest depth. This was as much about creating a cluster of balancing coloured shapes as drawing a conventional layout with the grapes as the focal point of the painting. My rough colour sketch included a little more sky than the photograph to balance the composition and I kept the village in the background pale to look distant.

◀ The single bunch of grapes dominates the foreground in this colour study, with just a suggestion of the mass of vines receding into the distance.

Top technique

A reasonable drawing is essential if your grape painting is to be successful. For a three-dimensional appearance overlap the rounded shapes. Vary the sizes, too, with smaller ones at the back and larger ones in the front and especially at the top of the bunch.

When you paint the grapes they need to look rounded, not flat, so build the colour in stages. Apply the first colour wet-on-dry, then blend subsequent colours into the previous layers. Give each shape a rounded look by graduating the colour and, if necessary, lift out a little colour to suggest reflected light. For the main highlight leave a small, unpainted circle on each grape.

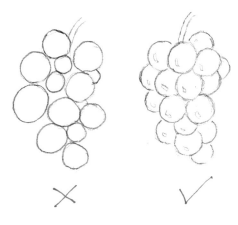

▲ Grapes drawn as individual ovals do not look realistic. Overlap the shapes and vary their sizes.

▲ Cool red and warm red, then warm blue and Burnt Sienna.

▲ Burnt Sienna and warm blue.

◄ Vary colour mixes to suit your painting, as shown here. Lift out some colour to show reflected light and leave a small unpainted area on each grape as a highlight.

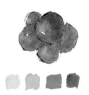

▲ Cool red, Burnt Sienna and cool blue.

▲ Cool yellow and Raw Sienna, cool red, Burnt Sienna and warm blue

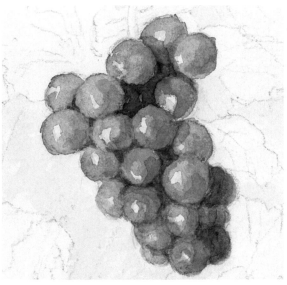

▲ Burnt Sienna and cool blue.

▲ Cool red, Burnt Sienna and warm blue.

▲ In the finished painting I painted the grapes with an underwash of cool yellow and Raw Sienna and, when almost dry, blended in a touch of cool blue and cool red. When this was dry I overpainted a pale mixture of Burnt Sienna and warm blue – a little stronger on the nearer grapes, and much stronger for the deep shadows.

Other useful tips

☐ Simplifying background detail

Background detail, such as a distant village, can enhance a picture, adding depth if it is painted lighter in tone than the foreground detail. This variation in tone, which occurs naturally as objects recede into the distance, is known as aerial perspective. It is also important to simplify background features and the initial drawing should suggest the general shapes of objects, but little else except the light and shade. A distinctive church spire or other tall building is always helpful to aid recognition in a painting, but be sure to make it in proportion with the size of the village and with foreground elements. Paint the intervening ground loosely with tones gently receding into the background area so that the foreground detail can dominate the painting.

Establish the general shape of the background area by painting a light underwash of cool yellow and Raw Sienna first. Just before this dries, add a touch of warm and cool red to the mixture and blend it in gently in places. Touch in the roof shapes using cool red and a little cool blue. When dry, add more blue for the darker roof areas.

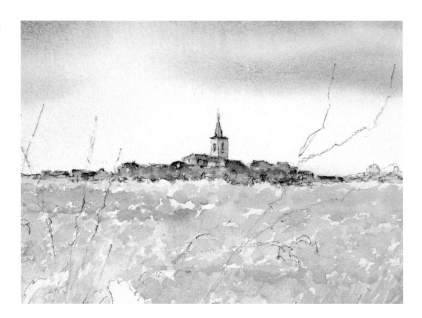

▶ Deeper shadows and window recesses in the buildings are simply indicated. Strengthen them by adding Burnt Sienna and warm blue to the colour mix used to paint the darker roof areas. A ragged line below the village maintains a natural look.

◀ Painting a mass of foliage can present many problems. In this detail virtually dead leaves were impossible to define accurately, so I made them fairly random in shape and size to simplify them. I built the colours up gradually using combinations of mostly warm and cool yellows and reds. The foreground leaves were made more distinctive and stronger in tone and colour, with deep blue-violet shadows between to make the leaf colours stand out in contrast.

Finished painting

The graduated sky, with a light patch at the bottom, adds to a feeling of depth. This is enhanced by the light tones of the distant village and the loose treatment of the intervening terrain. Warmer, stronger foreground colours also play their part, bringing the grapes clustered on the vine forward in the painting.

The Last Grapes on the Vine 44 x 30 cm (17½ x 12 in)

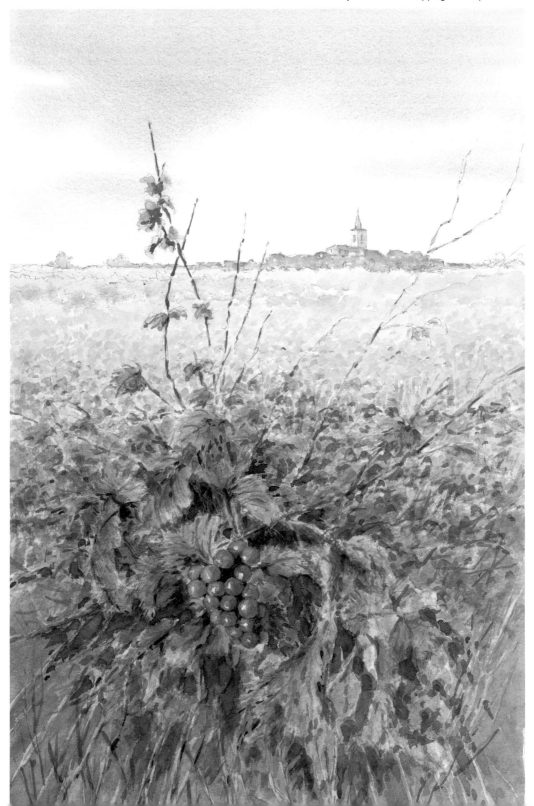

Improving a foreground with texture

A scene such as a field that looks attractive in reality can look quite dull in a photograph, but you can make it appear more interesting if you give more texture to its surface. Adding an additional feature like farm machinery can also offer an alternative focal point for interest.

Planning the painting

My initial idea was to include a large area of sky in the painting by lowering the horizon, so making light of the lack of foreground interest. The large trees and overhanging foliage that had crept into the edges of my photograph of the landscape were ideal to frame the view.

In my rough pencil sketch I also brought the group of farm buildings much more to the fore to provide interest for the viewer. I made my sketch on location and while I was drawing, having done quite a bit of work planning the composition, a tractor appeared and started ploughing the land. Incorporating it into the painting allowed me to create a stronger focal point than the rather distant farm buildings and also gave me a chance to include some textured terrain.

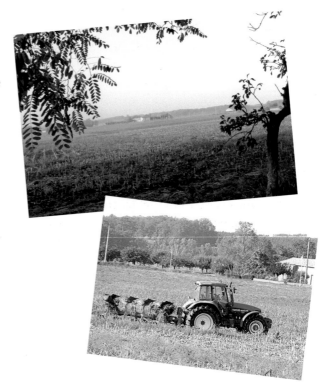

▲ Distant farm buildings and a tractor at work in the fields at Caudecoste in south-west France.

◀ In this pencil sketch I used the foreground trees to frame the view.

▼ I overlaid a sketch of the tractor on the partly finished drawing of the scene to assess whether its size and position were suitable.

Top technique

Paint stubble with ragged horizontal brush strokes, using a medium round brush. First give the whole area a light wash of cool yellow, then add cool blue and use the resulting pale green for any areas of grass. Wash Raw Sienna over the stubble, then add a little warm red and cool blue to the paint to neutralize the colour. Use this mixture to darken the furrows. Paint darker grass using cool yellow and blue toned down with Raw Sienna. Emphasize the furrows with a neutral brown mixed from cool blue with Burnt Sienna, making the nearer rows slightly darker.

Add warm blue to the green mix for foreground grassy tufts. Use a rigger and a neutral brown mix of warm blue and Burnt Sienna to paint ragged texture on the uneven ground. Paint shading on rocks and stones with cool blue and a little Burnt Sienna, then darken it by adding warm blue and more Burnt Sienna. Use this colour to add more texture to foreground grass, too.

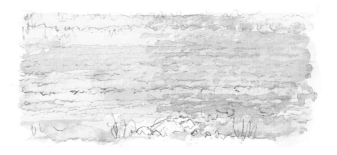

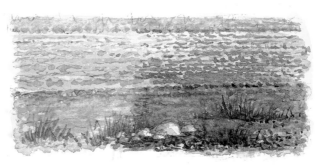

▲ Stubble, ploughed furrows, rocks, stones and grass all add texture and interest to a composition that features a flat field in the foreground.

Finished painting

The distant farm buildings were enlarged slightly from the size seen in the photograph, then overlapped by the tractor to create a composite focal point. The foreground stones were enlarged as rocks to add interest and the trees repositioned to retain interest within the central area of the picture.

Farm Buildings at Caudecoste
38 x 56 cm
(15 x 22 in)

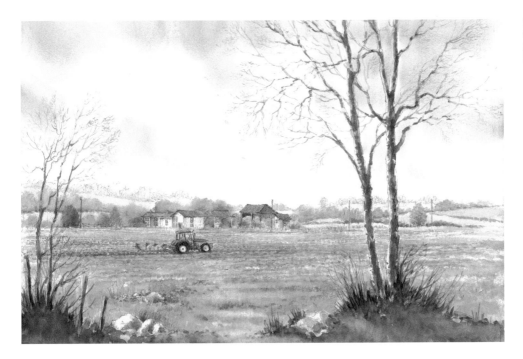

Using white paper to suggest snow

There is surprisingly little actual white in a snow scene. Much of the surface of the paper is covered in pale shadows of various colours and it is the shapes of these that expose the slopes and undulations of the underlying terrain. Unpainted areas are the best way to suggest pure white highlights on snow, with cool blue graduated washes for shaded areas and hollows.

Planning the painting

Snow is a very rare occurrence in the part of southern France where these photographs were taken. In fact, soon after this modest fall, snow was already glistening in bright morning sun. By lunchtime all traces were gone, so the reference pictures were a useful record of the scene. I took both a wide-angle shot and a close-up of the distant buildings as they would make an interesting subject on their own.

Although the photographs captured the scene accurately I felt they would benefit from a little artistic licence in planning a painting. The foreground trees acted as a barrier in both scenes when viewed as a potential picture. So, in my rough sketch, I repositioned the trees, placing the two thinner ones together towards the right and reducing the height of the left-hand one. This provided a clear view of the

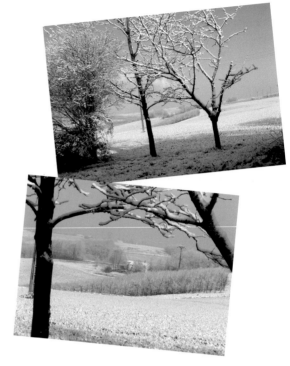

▲ Wide-angle and close-up views of snow-covered fields and farm buildings near Bardigues, France.

distant buildings, which I enlarged. I also changed the shapes of the buildings a little to give more scope for colour that would contrast with the bluish shaded areas in the snow.

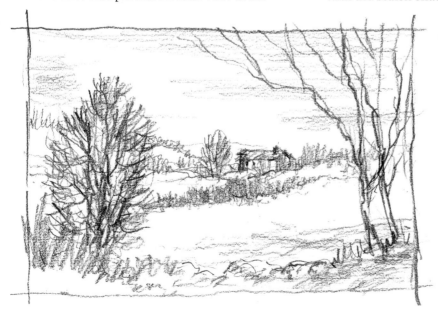

◀ A rough pencil sketch enabled me to plan a composition that combined the focus of interest of both photographs.

Top technique

To create the effect of snow on fields, damp the paper first before blending in a pale mixture of warm and cool blue with rounded, sweeping brushstrokes to match the slope of the terrain. This leaves soft-edged areas that suggest snow in shadow. Simply leave unpainted paper for the areas of lighter snow.

To increase the rounded effect of the drifts of snow graduate the colour, working from light at the top to dark at the bottom for the deeper, shadow areas. Blend in darker blue here and there for emphasis and a little cool red to lift the shadow areas. When dry, use the same mix to paint heavier shadows wet-on-dry and add a little Burnt Sienna to grey the colour for even darker shadows. Use the same mix a little paler to paint distant trees to separate the fields.

▲ The snowy expanses in this colour sketch are made up of different areas of pale colour that describe the shadows and hollows in the landscape.

Finished painting

Small residues of snow on the branches of the trees were achieved by reserving the white of the paper with masking fluid. On rough paper, as used here, it is difficult to remove, but I found that using a rolled-up thin latex glove did the trick. Most of the remainder of the snow is unpainted paper, except where light shading was used to emphasize the contours that indicated the gentle slopes of the covered fields.

Snow in the Valley 36 x 55 cm (14 x 21½ in)

Saint-Circ-Lapopie 36 x 53 cm (14 x 21 in)

Buildings and Townscapes

Finding the right perspective

In this scene the cottages are above eye level, but because they are built on a slope they are all at different levels. Although there is no need for the artist to achieve total accuracy, the use of perspective is helpful in drawing shapes such as these at the right angle. As the houses were built in a line, they all share the same vanishing points.

Planning the painting

I discovered this attractive cluster of Welsh cottages on my second visit to the location. On my first visit I stopped some way back down the lane to sketch a single cottage and failed to see this spot just around the bend. It is always worth exploring further.

I rather liked the multi-limbed tree and the undulating dry-stone wall. The light was shining on the roofs, turning the grey slate lighter, almost matching the sky. I felt that I could use some artistic licence to overcome the uninteresting foreground to the right.

The sketch made on site was done in a hurry, but I took more trouble than usual over the drawing I did back at the studio. Moving the large

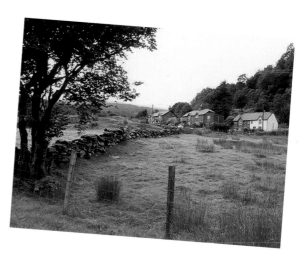

▲ These attractive stone cottages at Dolwyddelan in Wales have simple shapes.

tree inwards enabled all of it to be included and allowed a little more of the field beyond to show. I compressed the foreground field, enlarged and added to the fence posts, and also added an open gate to further improve the composition and invite the viewer into the painting.

▶ In my pencil sketch I decided to draw the field with an open gate, leading the viewer right into the composition.

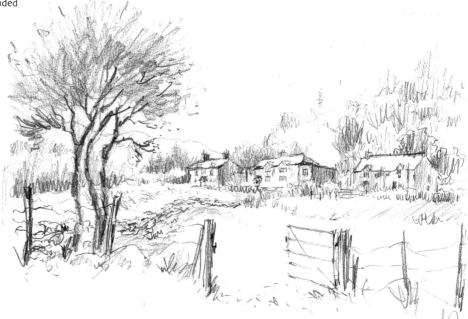

Top technique

Perspective has little effect on buildings when viewed from the front and at a distance. The lines of the roof, gutters and windows appear roughly horizontal. To locate the horizon line (eye level) extend your hands forward in front of your eyes – your fingers will be pointing to it.

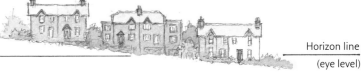

▼ Notice that although these houses are built on a slope the lines of the structures are all horizontal.

Horizon line
(eye level)

▼ Draw guidelines on your photograph or sketch to find the position of the vanishing points.

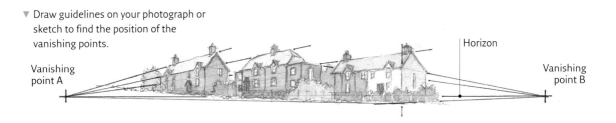

Horizon

Vanishing point A

Vanishing point B

With buildings viewed at an angle and from below, the lines of the roof, gutters and windows no longer appear horizontal, but slope down towards common vanishing points on the horizon line (see above). To find these on your reference photograph, draw the horizon line, then lay a ruler along the sloping roof and gutter lines. The point at which these intersect the horizon line will be the vanishing point (A). Use the same method to determine the position of the other vanishing point (B), by aligning the ruler with the top corners of the ends of each building.

Vanishing points can be close or far away from a building according to your viewing position. The diagrams below show two viewing positions – one close to the building and another further away. The line X-X, shown at right angles to the viewing line, indicates the picture plane. In elevation this would be, in essence, your drawing paper. Imagine it as a window through which you are viewing the scene and are drawing it on the glass. This precise approach is intended to help you understand perspective, but keep your drawing looser on the finished painting.

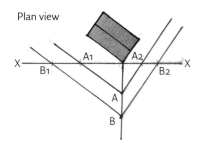

Plan view

▲ Lines from each viewing position parallel to the sides of the building intersect the picture plane at two pairs of vanishing points (A1/A2 and B1/B2). Vanishing points from the nearer viewing position A are clearly closer to the building than B.

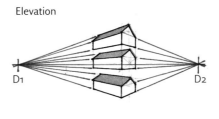

Elevation

▲ The middle building is at eye level, the top one on a hill and the bottom in a valley, yet the vanishing points are the same in each case. Because these buildings are quite distant from the viewer, the vanishing points (D1 and D2) are some distance away on each side. Note also the shallow angle of the guidelines.

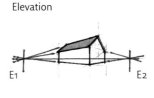

Elevation

▲ Here the viewer is closer to the building, so the vanishing points (E1 and E2) are also closer to the building. Note the steeper angle of the guidelines for the roof, gutters and windows.

Other useful tips

☐ Avoiding unrealistic fir trees

Many painters produce fir trees that look too straight-sided and symmetrical, but they should have a more random shape. Draw the trunk with a broken vertical line to show the height, varying the heights for a cluster of trees. Upper branches are short and slender, reaching up towards the sky. Further down the branches are longer, projecting laterally at first, then even longer as they droop down with the weight of foliage on them. Use slightly curved pencil lines to achieve a natural look. Paint distant trees using a pale blue-grey or blue-green mixture.

▲ Vary the heights of firs and allow the bottoms of the trees to blend into the foliage. Paint distant ones as pale blue silhouettes.

1 For near trees draw a few vertical marks for the trunk (this is partly hidden by foliage).

2 Paint the foliage with a small round brush using a pale mix of cool yellow and Raw Sienna.

3 Before this dries, add cool blue to the mix and blend in. After painting the top few upward branches, use short left-to-right and right-to-left brushstrokes with a slight curve.

4 As the paint dries, add warm blue to the mix and overpaint, adding more colour on the side away from the light. Use a rigger to pull a few fine strands out from the foliage to 'loosen' it.

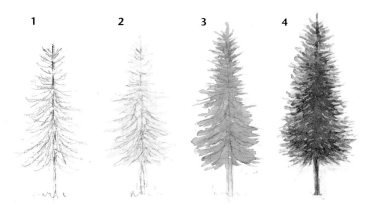

☐ Painting rustic country fences

Vary the height and width of country fences and place them randomly. Draw them roughly with a soft pencil first and set the bases in rough grass or a stony area. Use a flat brush to paint rustic-looking posts. Pull the brush back and forth on the palette to produce a chisel edge. Then place the edge of the bristles vertically on one side of each post and pull the bristles sideways to fill the width required. Build the colour in stages, leaving a lighter edge on one side so that the post looks solid and three-dimensional.

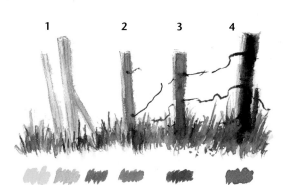

1 Start with a pale mix of cool yellow and Raw Sienna, then blend in warm red before this dries.

2 When almost dry, mix warm red and cool blue and overpaint, leaving a light streak facing the light source.

3 Add warm blue and Burnt Sienna to strengthen the mix and apply this to add solidity to the post.

4 Strengthen the mix further with more warm blue and Burnt Sienna to paint the post. Use this same mix and a rigger to paint wires, leaving a few breaks.

▶ The farm gate in the foreground is open to entice the viewer into the scene – a closed gate would act as a barrier. The gate appears much narrower than its opening in this position. The horizontal rails are equally spaced but if the gate is set at an angle as here, lines extended from each rail would converge at the same point on the horizon.

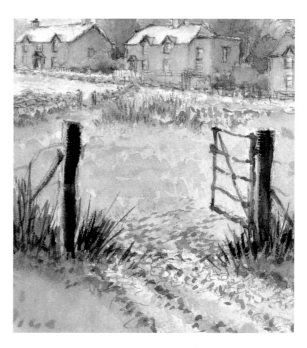

Finished painting

I avoided making the dark blue-grey gate look new – a slight raggedness ensures that it looks well used. Old roofs and walls tend to sag, so I also avoided drawing them too formally. Note that the chimney stacks sit astride the roof, not perched on top of the ridge tiles. Two of the buildings here reflect the sky colour on the roof, so they have just a touch of the sky colour on them.

Cottages at Dolwyddelan 36 x 51 cm (14 x 20 in)

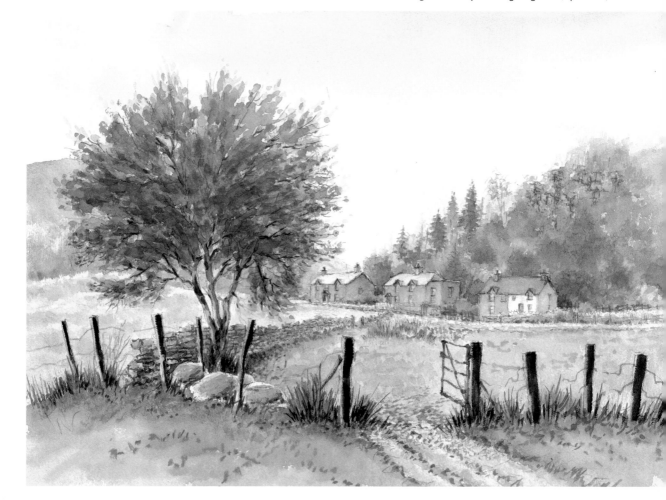

Conveying the effect of strong sunlight

When painting a scene in bright sunlight, the cast shadows are very strong and clearly defined. Make shadows stronger than usual and let the cast shadow of one object overlap or highlight the edge of another to bring out its shape.

Planning the painting

My reference picture was taken from a recently unearthed slide that I took nearly forty years ago on a visit to Athens. Although the colours are somewhat exaggerated, it has captured the structure of this wonderful ancient building, which was bathed in strong sunlight at the time.

In my painting I wanted to highlight the strong shadows that accentuate the complex shape and huge bulk of the edifice. I decided to include a few of the tourists who were milling around to give a sense of scale to the scene.

A colour study helped me tone down the intensity of the sky and I moved the viewpoint slightly to make the building look more imposing.

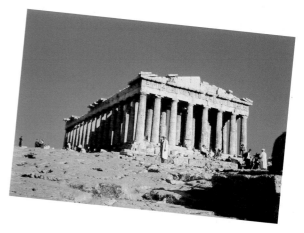

▲ This view of the Parthenon on the Acropolis, Athens, dates from the 1960s.

Although the strong shadows add to the feeling of bright sunshine I wanted to avoid making them almost black or unrealistic-looking. I settled on various shades of blue-grey, with lighter mixes of the same colours for the foreground rocks.

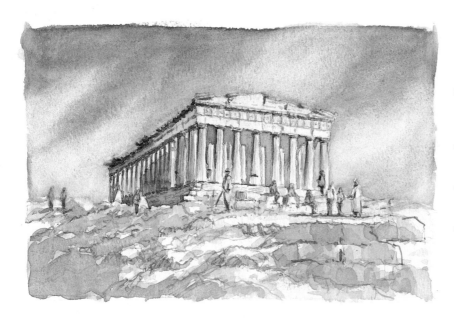

- Sky colour is made less intense and sweeps of light cloud introduced.

- Building moved to the left to improve the composition.

- Visitors repositioned for better balance.

- Shading on the foreground rocks is emphasized to highlight shape and bulk.

Top technique

When the sun is high in the sky the shadows cast are very strong and subtle tones tend to be burnt out. Bold shadows fall from one object onto another, defining the shapes.

Try a simple exercise using a strong light source. Below it, to one side, arrange a few household items such as tins, candles or boxes to represent blocks and columns. Bring out the heavy shading and cast shadows using a simple pencil sketch, then try a painted version. A simple mixture of warm blue with a touch of Burnt Sienna makes a useful mix, but any strong dark colour could be used. For the soft-edged shading on round columns, damp the side closest to the light before applying the paint with a vertical brushstroke.

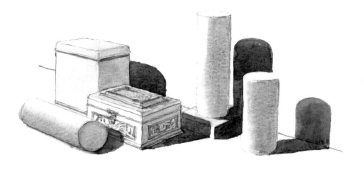

▲ When painting a scene in bright sun, make shadows bolder than usual and let the cast shadow of one object fall on the edge of another to emphasize its shape.

Finished painting

I stressed the strong shadows to bring out the essence of the building, but avoided making the tones too heavy and overpowering. Coupled with the wispy clouds across the sky, this gives the painting a slightly atmospheric look that I believe suits such a historic structure. The random figures lend a sense of scale and add interest.

The Parthenon, Acropolis, Athens 38 x 55 cm (15 x 21½ in)

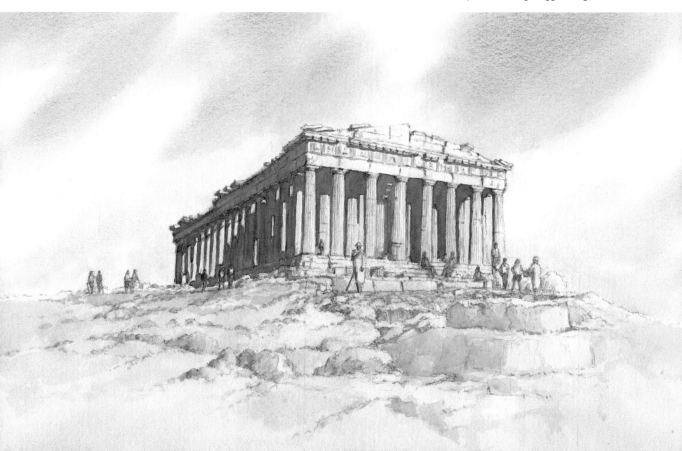

Painting circular buildings

Circular buildings can pose problems for artists, but if you use perspective it is easier to work out the shape. Strong shading is needed down one side to bring out the shape of the roof, while columns should be shaded on the side away from the light to indicate roundness.

Planning the painting

The most convenient viewpoint from which to sketch this charming old corn market at Auvillar in south-west France meant that a large tree appeared right in the centre of the subject, hiding the rather attractive pointed top section. To overcome this, I changed position rather than using artistic licence to remove it. There is a great temptation to include everything in a scene like this where there are so many buildings of real character, but it is important to try to isolate the main subject from the background.

I watched amateur artists painting this scene and often they selected just part of it as their subject or filled the entire paper with the building. I preferred to include all of the building, lots of sky and some of the cobbled foreground. I decided to use strong shadows and shading to bring out the shape of the building.

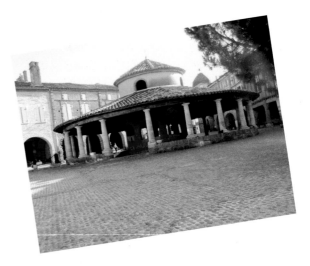

▲ The attractive old corn market at Auvillar in south-west France.

Moving the subject slightly off centre improved the composition. One or two figures would add realism to the scene and prevent the painting from looking like an architectural study.

▼ In my colour study I drew a few guidelines before putting in just some of the cobbled stones to lead the eye to the building.

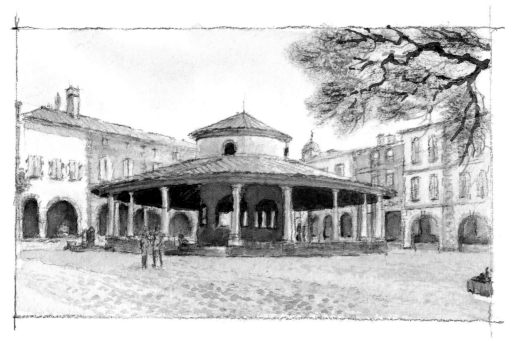

Top technique

Achieving the correct perspective for a circular building can appear complex, but there is a simple way to do this. In this painting the base of the building is viewed from slightly above and the underside of the roof is seen from below. At eye level these circular shapes appear as ovals or ellipses – the depth of each oval shape or ellipse varies according to how far above and below it is from the viewpoint.

A simple way to avoid a lop-sided ellipse is to use a rectangular box shape as a guide. Decide the width and depth of each oval, then draw a rectangular shape to correspond. Draw diagonals from the corners to produce a centre point from which you can check that a series of ellipses line up with each other. Use the guidelines to draw the curved lines so they balance in each section of the rectangle.

A less challenging approach is to overlay your reference photograph with a sheet of drawing film and 'square up' the building on a grid. Then transfer the drawing to a larger piece of art paper by using larger squares.

Paint the top of the building using strong shading down one side. Indicate the tiles loosely, again applying strong shading on one side. The rest of the building consists mostly of columns, which can be painted with pale Raw Sienna dulled down with a touch of blue and red. Again, shade them on the side away from the light to bring out

their rounded shape. Paint heavy shadows under the roof for contrast – this will accentuate the lighter tone of the surrounding pillars.

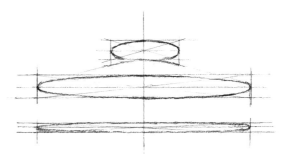

▲ Assess the width and depth of each oval shape and draw a rectangular box to match. Draw ellipses into the rectangles, using them as a guide.

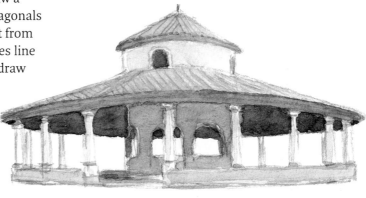

▲ Emphasize the rounded shape of the building with strong shading down one side of the top, on the sides of the columns and under the roof.

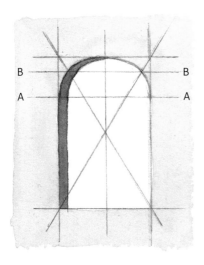

◄ To construct the shape of an arch, first draw a rectangle, then insert diagonals to find the vertical centre line. Draw a horizontal line where the curve starts on each side (A-A). Then draw the curve. An additional horizontal line (B-B), where the curve crosses the diagonal, allows you to check that one side matches the other. Suggest the thickness of the wall by drawing a vertical line to a suitable width and curving it upwards to a spot just past the centre line.

Other useful tips

☐ **Drawing and painting cobbled surfaces**

Attractive rows of stone cobbles often cover large areas, but there is no need to include all of these in a painting. Just add a random selection to enhance the picture and attract the eye to the main subject. Use reference photographs and a long ruler to determine the location of the vanishing point on the horizon line where lines through the rows of cobbles all meet (even if out of view of the camera). Place this on your paper, then draw guidelines from it to put in some randomly placed stones. Draw them sparingly, but include sufficient to suggest that there are more in the actual scene.

Use a light wash of Raw Sienna to paint the individual shapes. While still damp, overpaint pale variations of warm and cool red with a hint of cool blue added to the mixes. When dry apply more cool blue here and there. Add a touch of Burnt Sienna to grey the mixture to add emphasis and highlight the rows here and there. Use slightly stronger colour in the foreground.

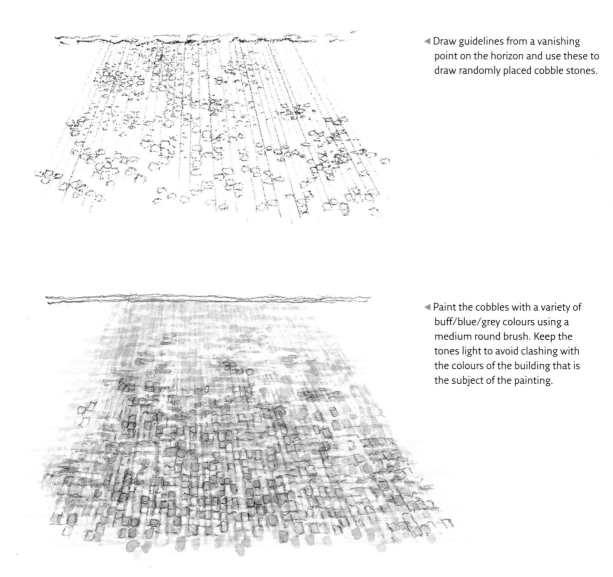

◄ Draw guidelines from a vanishing point on the horizon and use these to draw randomly placed cobble stones.

◄ Paint the cobbles with a variety of buff/blue/grey colours using a medium round brush. Keep the tones light to avoid clashing with the colours of the building that is the subject of the painting.

▶ A distinctive cylindrical shape, topped with a cone-shaped roof, makes up the top section of the building. This is painted with strong shading on the side away from the light to emphasize the contours. Note the deceptive angles of the rows of tiles.

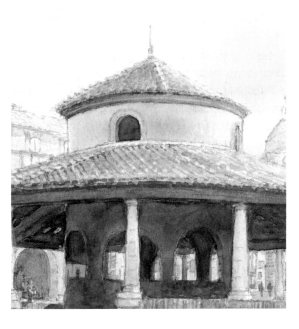

Finished painting

Warmer, stronger colours and tones were used to make the main building stand out from the surrounding ones. Just as in an open country scene, this adds to the feeling of depth. The tiny figures help to show the size of the structure. I omitted the overhanging foliage at the edge of the photograph as this was a distraction.

The Old Corn Market at Auvillar 38 x 53 cm (15 x 21 in)

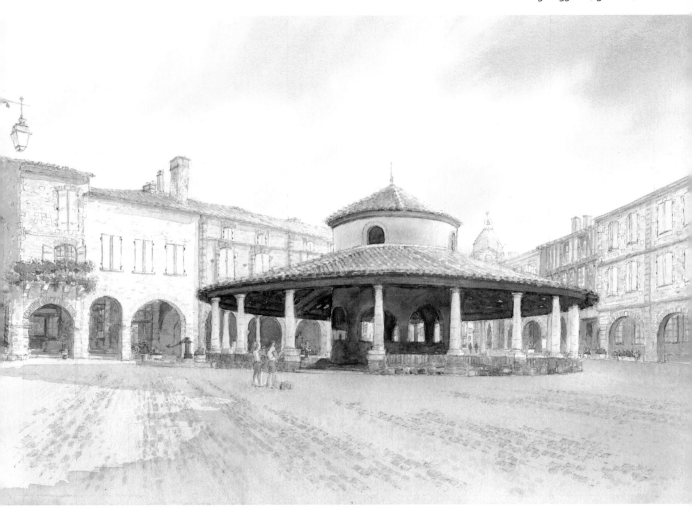

Painting dramatic skies

There are many ways to paint skies that have huge masses of dark clouds. The technique of painting wet-in-wet is involved for all of them, so timing, strength of colour and the amount of water on both brush and paper is crucial.

Planning the painting

The well-known landmark of Mont St Michel in Brittany makes a splendid subject for a painting. I had limited time to take my reference photograph, thanks to heavy showers and the difficulty of parking, but I managed to find an interesting angle from the grass verge.

The temptation with this kind of subject is to include too much detail, with the result that the painting resembles a picture postcard. I decided that accentuating the overcast sky would make a good backdrop for the imposing spectacle. However, it would be important to leave gaps between the clouds and vary their shapes and sizes so that they would not dominate.

The curved verge and foreground strip of water lead the eye nicely into the picture. While working on my colour sketch I decided that the road was distracting, so I omitted it and extended the grassy bank instead.

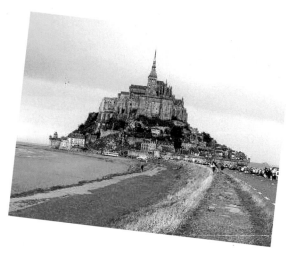

▲ The much photographed French landmark of Mont St Michel is inspiring even on a dull overcast day.

I brought the strip of water in from the side of the painting to emphasize the flatness and introduced grassy stems to break up the smooth edge to the bank.

My problem here was to feature the building without bringing it forward too much, so I repositioned it to make it less central and left a light patch in the clouds to draw attention to it.

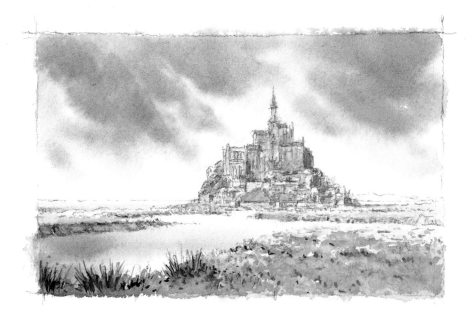

◄ I moved the main subject to the right in this colour study and decided to balance this with a heavy bank of cloud to the left.

Top technique

Here are two simple ways to paint bold skies. In both cases the paper must be damped all over the sky area first.

One way is to use cool blue and Burnt Sienna to paint the cloud shapes. Add warm blue to the mixture and more Burnt Sienna to blend in shading at the bottom of each cloud mass while the paper is still damp.

Another method is to mix three primaries for the greys. Mix Raw Sienna and warm red with cool blue, then warm blue, for the cloud shapes. Cool red could be used for the red and various yellows instead of Raw Sienna, so the choice is huge. Use a strong mixture when adding shading to clouds when the paper is damp, not wet, to avoid back-runs.

Finished painting

Leaving a light gap in the clouds around the focal point of the composition helps to focus the viewer's attention in the right place – on the magnificent building. The angled inlet leads the eye into the scene, while strong foreground colours help to create a sense of depth.

Mont St Michel, France 33 x 51 cm (13 x 20 in)

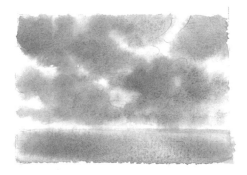

▲ Cool blue and Burnt Sienna can be used to paint bold clouds. Ensure the paper is damp, but not wet, then add warm blue for shading.

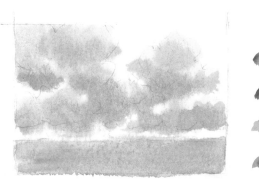

▲ Try mixes of three different primaries to make greys for banks of clouds.

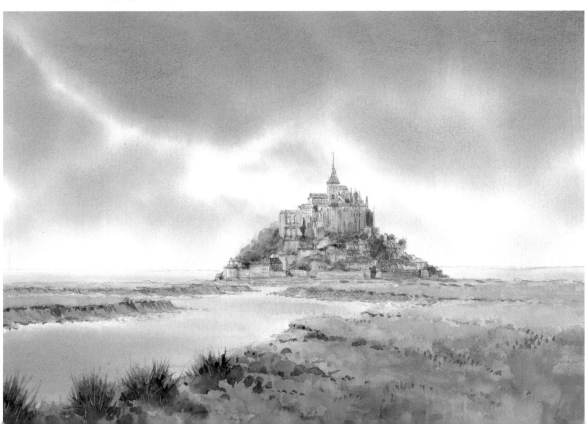

Creating atmosphere with washes

To create the atmosphere of a really wet day, emphasize the lights reflecting on wet roads and pavements from cars and buildings. Adding puddles and windswept figures and their reflections to the composition will enhance the mood of the painting.

Planning the painting

Wind and rain may dampen your spirits, but that is no reason to put away the camera. Such weather provides a chance to capture some evocative and atmospheric scenes, especially at dusk when only the lights of cars and distant buildings offer an antidote to the gloom.

My photo taken from a moving car inspired this painting. From this position, the lines of the buildings, gutters and kerbstones, including those in the reflections, all direct the eye in one direction to the bend in the road.

I made a brief sketch using ballpoint pen and decided to concentrate the composition on the activity in the wet street itself in a portrait format.

▲ This rainy scene was a still taken from a video shot through the car window while the vehicle was moving. It captures the general feel perfectly.

- Dark sky at the top provides balance.

- Leave the light area over the mountain tops.

- Directional marks on the road guide the viewer's eye into the picture.

- Sky and road are painted together so the road reflects the sky.

- Lights in shops are reflected on the pavement and road.

- Car lights and reflections contrast with the dark surroundings.

Top technique

Before starting to paint the background washes that will give the scene the required overcast appearance, draw guidelines and apply washes with directional emphasis to match. Here, one-point perspective is used – where all the lines diverge to a single vanishing point – in this case, at the bend in the road.

After damping the paper all over, paint the main areas with an underwash of cool yellow and Raw Sienna. When dry, paint the sky, road and pavements in the same colours, using cool and warm blue and a little Burnt Sienna. Graduate the dark wash over the sky from dark to light down to road level, then light to dark to the bottom of the picture. Use directional brushstrokes to match the guidelines and leave a light patch in the centre to attract the eye.

Paint the mountain backdrop wet-on-dry in layers of varied tones to suggest depth. Lift out a little colour at the tops to suggest mist or cloud.

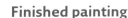 Early washes are applied in stages, graduating them from dark to light at the top and light to dark at the bottom, to suggest depth.

Finished painting

Although it is not practical to paint rain, this example shows how the effect of a rainy day can be conveyed with multiple wet-in-wet washes and strong reflections, making a drab scene look interesting. The buildings, cars, people and lights are painted in neutral colours and their reflections are painted onto pre-damped paper to retain the wet look. Strong directional bands of colour are painted on the road wet-in-wet to direct the viewer's eye to the bend in the road. Puddles are suggested by leaving light patches showing through dark areas, especially in gutters.

Rainy Day in Town
38 x 25 cm (15 x 10 in)

Painting figures in street scenes

Including figures in a street scene can really bring it to life, but they need to be positioned carefully and to be in proportion to the buildings. Use reference material wherever possible and try to make sure the people are doing something.

Planning the painting

Exploring the side streets in French towns and cities can be very rewarding and my trip to the attractive town of Brantôme was no exception. This narrow street is typical of the area and the pavement cafés, lanterns and well-stocked stalls between the tall buildings all add to the quaint atmosphere. I waited for a rare gap in the flow of people before taking a reference photograph.

The potted plant in the foreground was rather distracting, so when I sketched my initial idea I reduced this in size and changed its shape before turning my attention to the figures.

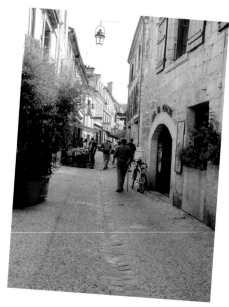

▲ A typical street in the popular tourist town of Brantôme in France provided useful reference.

I decided to remove the figure walking towards the camera in the middle, which allowed sight of the pavement café behind and would add depth to the painting. I added a figure on the left, but later changed the composition to a pair in conversation and made them smaller.

I planned to create a light patch in the lower part of the sky area and extend this lightness to include the distant buildings disappearing round the bend. This would also emphasize the feeling of depth, which can be quite difficult in a painting of a street scene.

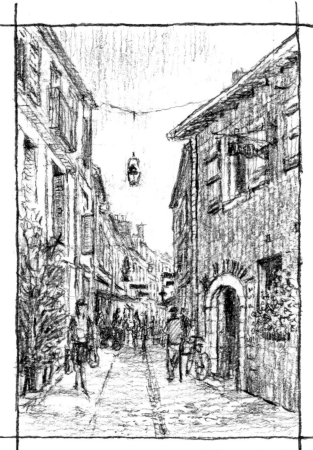

◀ In my rough pencil sketch I omitted the figure walking towards the viewer as this blocked part of the scene.

Top technique

Adding figures to a scene gives a sense of scale as well as movement, but can make or break a painting. Position them carefully in proportion to the surroundings and arrange them to suit the composition. Draw the outlines loosely, remembering to keep heads and feet small.

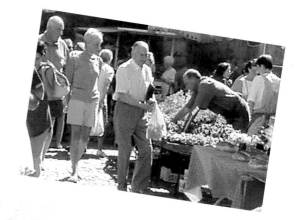

▲ Markets are always excellent places to photograph interesting people.

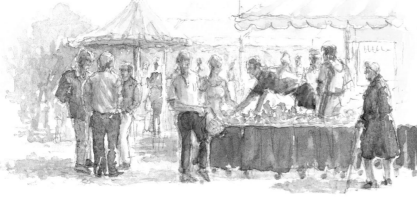

◄ Backlit figures are effective because they require less detail and their cast shadows indicate a sunny day.

Painting groups of people in various positions is good practice. Paint heads, hands, arms and legs with Raw Sienna, then blend in a touch of red. Include shading in the garments when you add colour to them. If the figures are backlit, leave a light halo around the edge nearest the light source to make them stand out from the background. Paint cast shadow on the ground with a mix of warm blue and cool red, and darken shading on features using the same mixture.

Figures that are actually doing something rather than just standing still will enhance your painting. A seated couple may be in conversation, and a father and child holding hands gives a natural look. Appropriate colours for their clothes should add to the scene you are painting.

▼ Paint figures that are moving or doing something. Choose colours for the garments that will enhance rather than detract from the main subject.

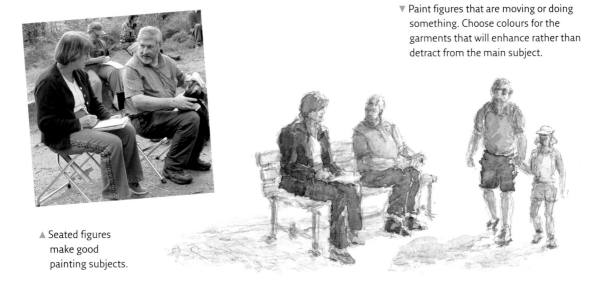

▲ Seated figures make good painting subjects.

Other useful tips

☐ Finding the right perspective on a bend

Buildings constructed in a row on a curved road or street each have different vanishing points along the same horizon line, so they gradually appear smaller and less angled.

Here is a diagram that illustrates this in a way that is easier to understand. The outlines of the buildings are in black and the guidelines in red.

▶ Draw the horizon line (eye level) first and an angled box-shaped outline roughly in proportion for the first building. Place a vanishing point (A) on the horizon line to achieve the correct angles for the top and bottom of the building. Draw an upright for the second building (a little narrower than the first) and place a new vanishing point (B) to the right. Then connect lines from the top and bottom of the second building. Repeat for the other box shapes using vanishing points C, D and E, each of which will be slightly further away.

Try making a similar diagram for yourself using just two or three buildings. Assess the proportions of the outlines of the building using a reference photograph or an actual building. Remember that the sides of buildings are always vertical, although historical buildings may lean in or out in places through age – a photograph will often exaggerate any deviation from the 'true'.

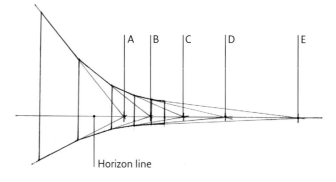

Horizon line

☐ Painting buildings in shade

When the sun shines in towns and villages it invariably puts one side of the road in shadow, with a long cast shadow traversing the road. These shaded areas add realism to your painting and help to emphasize the size and shape of figures, kerbs and other elements by providing contrast between light and dark areas.

For practice, sketch a simple street scene. Paint the scene first with normal colours and tones, with distant buildings a little paler. Then overpaint one side with a mixture of warm blue and cool red and extend the colour over the road for the cast shadow. Check on shadow shapes by mocking up a building with a cardboard box and place a strong light source above and to one side.

◀ One side of this street scene is painted normally, with buildings a little paler as they recede. The other side is overpainted with violet shadow that extends over the pavement and the road.

Finished painting

I repositioned some of the figures slightly and added more light and shade, which helped to give more contrast. Note that all the figures are engaged in various activities. The strong shadows emphasize the difference in tone between the buildings in the light on the left and those in shade on the right. The buildings in the foreground were painted with warmer, stronger colours to add to the feeling of depth.

Brantôme Street Scene 33 x 23 cm (13 x 9 in)

River Orb 36 x 52 cm (14 x 20½ in)

Lakes, Rivers and Bridges

Creating variety in summer trees

It is essential to create variety in summer trees because there is such a mass of green foliage. Trees in the far distance have a pale, bluish look because of the effect of aerial perspective, while those in the mid distance reveal many colours and tones.

Planning the painting

My reference photograph shows that, from the near bank of the river, the large background hill was too central, as were the two large trees. The on-site pencil sketch, although simple, was sufficient to suggest an interesting picture, but confirmed that I should move the trees slightly to the right to balance the composition.

▲ Don demonstrates on location in the scenic area of Snowdonia.

Bringing the river in from one side helped to achieve a flat look to the water and stopped it looking like a road, and I chose a low-level vantage point for maximum effect. This helped to compress the foreground area, so avoiding a large space with little interest. My colour sketch was completed on location and captures the main elements of the composition. I introduced stones and rocks sparingly in the foreground to balance other objects in the painting. The tufts and clusters of spiky grass add variety and additional interest to the foreground area.

▲ In the pencil sketch the two large trees are too central and need to be repositioned slightly. The larger one would provide more balance if lower on the bank.

▶ In this colour sketch the light areas in the sky and on the water are particularly effective, bringing the scene to life and attracting the eye of the viewer.

Top technique

Distant clusters of trees look pale, so use cool colours. Mix cool yellow and blue, with a touch of warm blue for variety, and overpaint with stronger tones. Use the sides of the bristles on a small round brush, keeping them flat to the paper to retain rough edges for the foliage.

For mid-distant woodland you need a range of greens. Try mixing first cool blue, then warm blue, in turn, with cool yellow, warm yellow, and then Raw Sienna. Vary the colours with stronger or weaker mixes and achieve further tones by adding a small amount of cool or warm red or Burnt Sienna to neutralize the greens.

For closer, individual trees vary shape and size as well as colour. Establish the overall outline, then draw the trunk so that it is not too wide, thin or conical. Branches where the trunk divides are quite sturdy, but they become progressively slender, extending to the outline. Some branches show through gaps in the foliage – ensure these appear connected to the tree. Paint the foliage with a light mix of cool yellow and Raw Sienna, and blend in a little cool blue while still damp. Darken the mix with more blue and a little red for a dull grey-green for the trunk and branches.

▲ Use cool colours and pale tones to paint distant tree clusters. Use warm mixes for foreground trees.

▲ Even with a modest palette you can mix many greens, so experiment by mixing different yellows and blues.

Before the foliage dries, blend in stronger cool blue and yellow, adding warm yellow and blue. Add more warm blue and a little Burnt Sienna to the sides and bottoms of clusters. Use the same two colours to darken the trunk and branches.

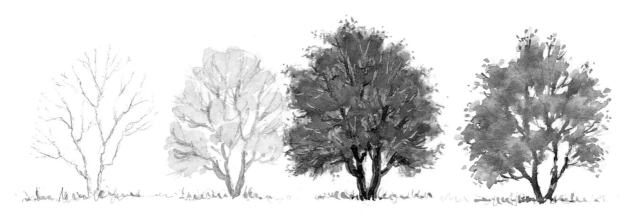

▲ Build up foliage in stages, leaving gaps between clusters for branches to show through. Use the side of the bristles on a small round brush or small squirrel mop for foliage.

Use a rigger for fine branches and tiny leaves at the edges of foliage for a looser look. The two finished trees show how different colour mixes can vary the appearance.

Other useful tips

☐ Painting grassy banks

Using the pencil with an up and down motion draw borders of grassy banks with a series of ragged broken lines. Make the nearer edge of each projecting bank roughly horizontal – if too angled the water will appear to run downhill.

Paint distant fields with a round brush and a pale mix of cool yellow with a little cool blue, then stronger colour for the mid distance. For nearer banks, start with the same colour and, while still damp, blend in a stronger mix using a hake with short vertical strokes and a fairly dry paint mixture. Before dry add warm yellow and Raw Sienna for variation.

Hold the hake vertically and press the bristles down along the edges of the riverbanks to release a rough dark edge of paint. Further darken the mixture with warm blue and apply this with a small round brush for grassy clumps. Finally, add more warm blue plus a touch of Burnt Sienna for a really dark blue-grey and emphasize the grassy tufts using a rigger.

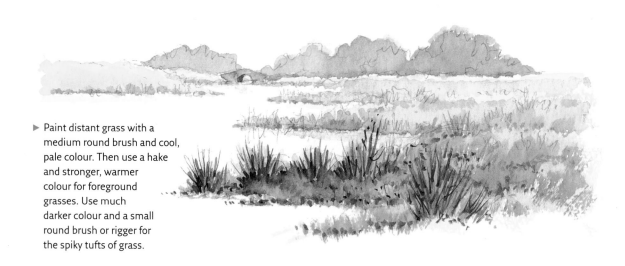

▶ Paint distant grass with a medium round brush and cool, pale colour. Then use a hake and stronger, warmer colour for foreground grasses. Use much darker colour and a small round brush or rigger for the spiky tufts of grass.

☐ Improving your hake

With some hake brushes, particularly if they are bushy, it is difficult to achieve a chisel edge. A way of improving a hake is to chamfer the edges of the bristles. First, damp the brush and remove excess moisture on a tissue. Squeeze the bristles with your fingers to remove additional moisture and to form as flat an edge as possible.

Hold the hake upright, then gently pull a sharp razor upwards repeatedly against the ends of the bristles to chamfer them. Turn the brush around and repeat on the other side. Lay the brush on a rubber cutting mat, place a steel rule across the end of the bristles and use a scalpel or craft knife to trim off 3 mm (⅛ in) for a crisp edge.

◀ Keep the hake upright while you chamfer the edges with a razor. The bristles will tend to curve backwards as you progress.

When using a hake, soak the bristles in clean water and then squeeze out the moisture. Dip just the ends of the bristles back in the water before loading the brush with paint.

▶ Notice in this detail how trees and shrubs on the distant hill were painted wet-in-wet for soft indistinct edges, using pale tones and cool colours.

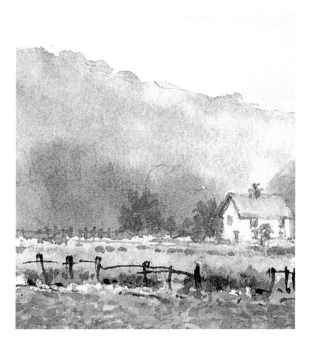

Finished painting

The low viewpoint creates a feeling of wide, open spaces. Note the lighter patch of water just below the bridge to attract the eye of the viewer to the focal point. The two dominant foreground trees, although still a little central in the painting, are deliberately different in size and colour and are each positioned an unequal distance from the bridge. The tree line in the mid distance is stronger in tone and richer in colour variation than the pale, far trees, but not so dark as to clash with the two large trees.

River at Dolwyddelan 34 x 48 cm (13 ½ x 19 in)

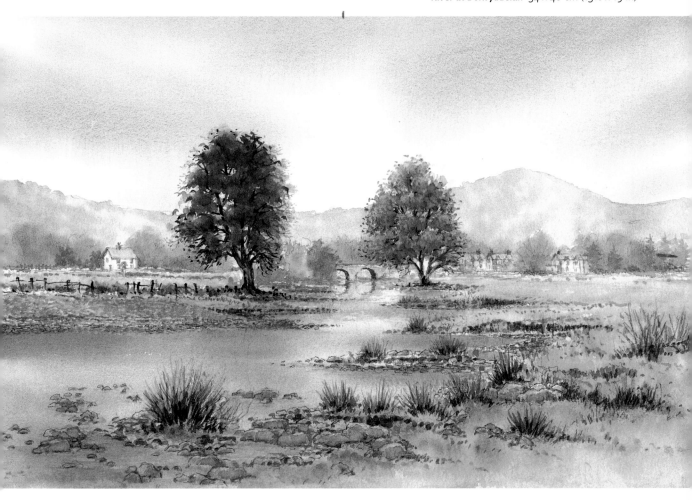

Painting simple bridges

The important point in featuring a bridge in a painting is to make the shape symmetrical, and its reflection a mirror image of the actual bridge. The reflection of the shadow under the curved opening can appear larger than the one above, depending on the viewpoint from which it is seen.

Planning the painting

The calm water provided a mirror-like reflection of this attractive bridge on a pleasant autumn day. The view from the top of the nearby steps was quite interesting, but a short walk down to water level provided a more paintable angle on the subject. I took both wide-angle and close-up photographs, which offered me good reference material and more choice of composition.

I decided that a wide-angle view would enable me to use the sweeping river shape to best advantage, leading the viewer into the painting towards the bridge. To allow the viewer to 'move forward' more easily I thinned out the rather overpowering foliage of the left-hand tree in the foreground in my planning sketch.

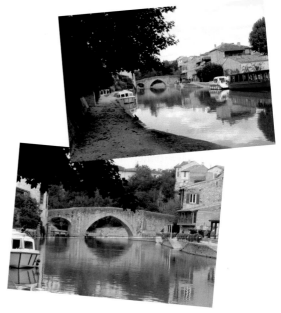

▲ Two views of the bridge and river at Nérac in south-west France.

▼ In my pencil sketch I planned my composition on a wide-angle view that leads the viewer's eye to the focal point – the bridge.

Top technique

Drawing and painting bridges and their reflections is not difficult as long as you follow some simple guidelines. The diagrams here will help you to become familiar with the basic shapes before you tackle a complete painting. At first glance they look complicated, but follow the instructions and there should be no problem. The guidelines are shown in red to make things clearer. Try drawing the arch first in your sketchbook rather than on an actual painting.

Paint the bridge by building up colour in layers, each time leaving a little of the previous one showing here and there. First apply a light underwash of cool yellow and Raw Sienna and, before this dries, blend in a touch of warm red in places. When dry, overpaint random stone blocks with a light mix of cool blue and red, leaving plenty of gaps. Before this dries, paint darker shapes with a light mix of warm blue and Burnt Sienna. Strengthen the mix to paint weathered areas along the parapet and the dark shadow and reflection under the bridge. Use horizontal brushstrokes to suggest the light ripples on the water surface, especially at the edges.

▲ Draw guidelines at water level below the bridge (A), the top (B) and, an equal distance below, the reflected line of this (C), all angled towards a vanishing point (off the page). Draw vertical lines (D and E) to indicate the width between the banks. Draw diagonals (F and G) from the corners of the resulting square. Where they intersect, extend a vertical line (H – the centre of the bridge). Draw an inner rectangle (J, K, L, M) to match the height and width of the required opening and curves to show the thickness of the bridge.

▲ Where the arch extends from upright sides, draw two extra guidelines (N and O). The curve starts where these lines intersect the uprights (L and M).

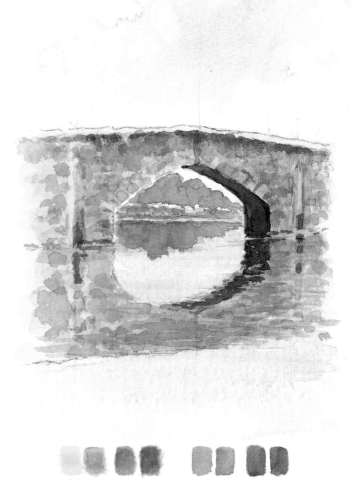

▲ For this colour study I drew some rough guidelines with a soft pencil before drawing an accurate shape of the bridge. The close-up photograph provided useful detail of the bridge.

Other useful tips

☐ Painting cloudy skies without back-runs

Here are two simple ways of avoiding back-runs, which usually occur when wet paint is applied to a too wet surface. Draw loose cloud shapes with a soft pencil and use a large brush for painting.

In the first method (below left) damp the paper with water and when the heavy shine has dulled, paint sky colour around the clouds. Stop short of each cloud and allow the colour to spread. The edges should be soft. If not, the paper is already too dry and it is best to let it dry completely, then damp the whole lot again. Alternatively, damp just the dried cloud areas and work the moisture out into the sky colour, avoiding excess water. Paint the clouds before the paper dries after adding a little Burnt Sienna to the sky colour to grey it. Leave some gaps and stop short of the sky colour to form a white halo. Just before this dries, use a slightly stronger mix to blend heavier colour over the lower part of each cloud.

In the second method (below right) apply the cloud colour first, and then the sky colour – again on damp paper. Mix a greyish blue from three primaries for the clouds, trying different mixtures of warm and cool colours. Add only tiny amounts of red and yellow to the blue to avoid 'mud'.

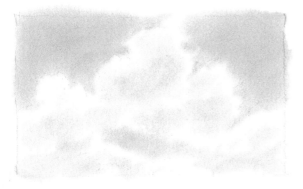

▲ Here the sky colour was painted first on damp paper, stopping short of the clouds to leave soft-edged shapes. Then the cloud colour was added.

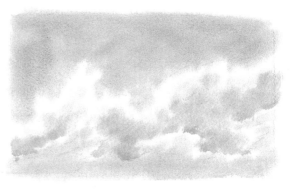

▲ In this example the cloud colour was applied first, then the sky colour painted around it – again on damp paper for soft-edged cloud shapes.

☐ Giving old tiles a weathered look

It is essential to draw and paint old tiles loosely, otherwise they will look too new. Use a soft pencil to draw the rows roughly and indicate the small shadows where they overlap, with a slight sag on the ridge of the roof to give an aged look.

Build up colours wet-in-wet to start with and use downward strokes to match the slope, leaving gaps here and there. When dry, add dark touches and texture with a little dry-brushwork.

▶ Build up colours with cool yellow and Raw Sienna, then blend in warm red and cool blue. Use sloping brushstrokes to match the angle of the roof. Use a warm blue and Burnt Sienna mix for random dark touches and leave unpainted areas in places. Overpaint gently with a little dry-brushwork.

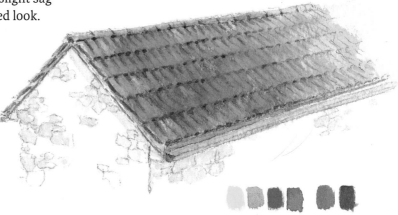

▶ Although the bridge and its reflection are painted loosely, the general shape is symmetrical and the reflection is a rough mirror image of the bridge above. From this angle only the tops of the background trees are visible.

Finished painting

In the finished painting, the overhanging foliage has been given a warm look to match the colour of the weathered roof tiles on the buildings. The shape of the large patch of blue sky matches that of the river area below. Muted colours add to a feeling of tranquillity and the pale distant trees increase the feeling of depth.

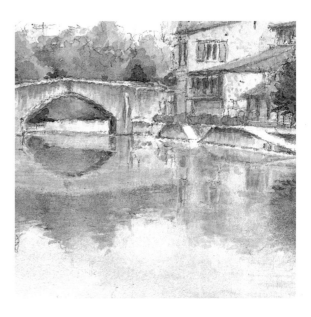

Bridge at Nérac 30 x 41 cm (12 x 16 in)

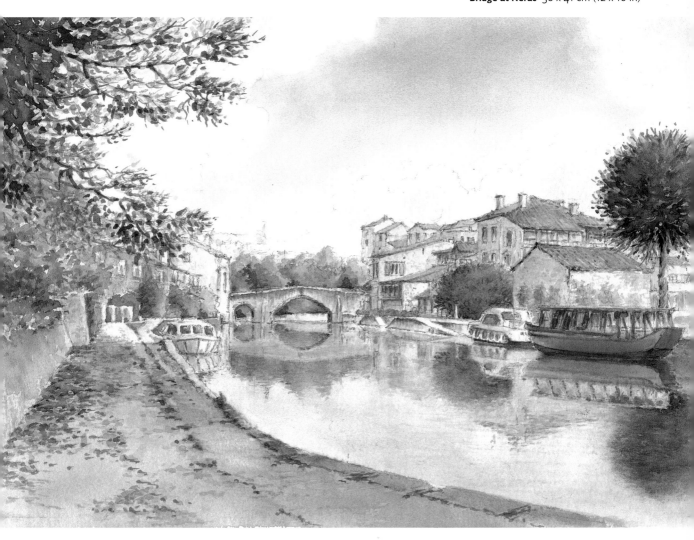

Painting fast-moving water

Fast-moving water looks best when pouring between dark banks or rocks that show it to good effect. Soon after a period of heavy rain is the ideal time to visit swollen rivers and dramatic waterfalls and rapids to catch them at their best.

Planning the painting

When I visited this river to photograph its dramatic fast-moving water for a painting it was still raining heavily. It was hardly the time to put up an easel and paint on location, so I explored the area looking for the best spot to take my reference photographs.

The huge birch trees surrounding the rushing water provided a colourful backdrop. I decided to let the trees take up the top two-thirds of the painting, with the three dominant trunks acting as a focal point – they would also lead the eye down to the water. I put my thoughts down in a quick pencil sketch made on the spot, which confirmed my rough composition. The rocks and the overhanging foliage were placed so as to keep attention within the frame.

▲ Fast-moving river at the Birks of Aberfeldy, Perthshire, Scotland.

The mass of background trees were very confusing to look at, so I decided to simplify them and leave gaps here and there for a hint of sky to show through. My intention was to create a wide variety of pale tones and colours in this area of the finished work to add depth and contrast.

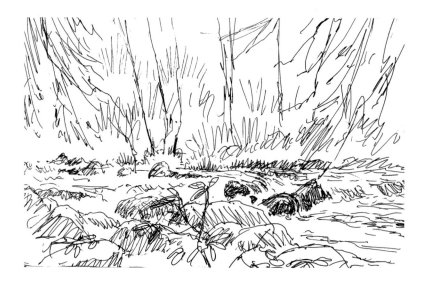

- Light patch of sky shows through the tree foliage.

- Slender vertical trunks contrast with the clumps of foliage.

- Overhanging foliage in each corner frames the subject.

- Emphasize the dark edge to the bank to create a distinct edge for the river.

- Leave the foam unpainted for foam highlights on the water.

- Make the foreground rocks dark to contrast with the paler tones of the water.

Top technique

Before working on the river, indicate the banks clearly with a series of short rough vertical pencil strokes to represent mud banks, grassy edges and solid rounded clumps of rocks. The tops of the rocks projecting out of the water are usually rounded by the flow of water and the shape where they touch the water is flatter. You will find that only the simplest of drawing, using rapid pencil strokes, is required to show the movement of water. Most of the paper will be left without any drawing on it and this is carried through to the painting stage.

▼ A few long sweeping pencil strokes suggest the movement of water over the undulating river floor and a few shorter strokes show the turbulence where it drops to a different level.

Leave much of the paper unpainted to suggest foam and sparkling highlights. Damp the river area and, when the surface is almost dry, brush in a pale wash of cool blue, applying it with a flowing movement using a small or medium round brush. Lift the brush off the paper here and there to leave unpainted patches. Before this dries, apply a slightly stronger mix in places, especially nearer the rocks, adding warm blue in places and also a touch of green mixed from warm blue and cool yellow. Where the water drops over rocky outcrops, wait for the paper to dry, then use rounded vertical brushstrokes with a strong dry mix to suggest dark streaks – a little Burnt Sienna added to warm blue is ideal for this. Leave unpainted gaps between the dark patches for contrast.

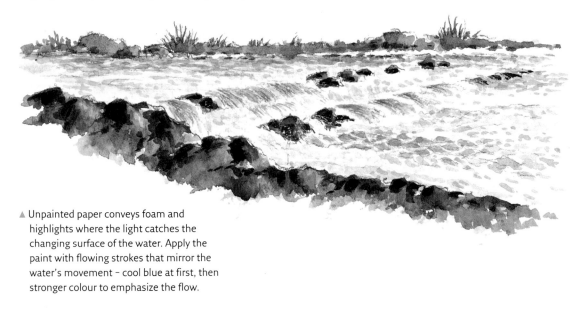

▲ Unpainted paper conveys foam and highlights where the light catches the changing surface of the water. Apply the paint with flowing strokes that mirror the water's movement – cool blue at first, then stronger colour to emphasize the flow.

Other useful tips

☐ Painting massed foliage

Build up complex background foliage in easy stages. Paint varied patches using cool mixes first, then overpaint wet-in-wet with stronger colour here and there. Before this dries, paint trunks and branches wet-on-dry, leaving gaps here and there or lifting out colour to suggest filtered light through the mass of foliage.

▲ Start by painting patches of foliage with pale cool yellow and blue mixes, then overpaint wet-in-wet with stronger mixes of cool and warm yellow with warm blue.

▲ Use the underpainting of overhanging foliage to indicate curved branches and a variety of small leaves, most of which are seen in silhouette.

Where an area is overshadowed with long hanging branches of heavy foliage you can use these to frame the subject. Build up this foliage in the same way as the background trees, starting with cool pale colours, then overpaint them with stronger, warmer colours. In this situation the foliage looks more effective if pulled in from both the top and the sides of the painting – a small amount on one side and a large amount on the other.

▲ Overpaint large areas of overhanging foliage with strong mixes of warm blue and warm yellow, strengthened with more warm blue and Burnt Sienna to give it a really heavy appearance.

Overpaint large areas of overhanging foliage with strong mixes of warm colour, strengthened and darkened to make it look weighty and to stand out from the background foliage. Use a medium round brush for the bulk of the foliage and the branches, and a rigger for odd leaves. When planning to introduce overhanging foliage to an almost finished painting it can be a good idea to paint clusters on scraps of paper first and lay them on the painting to ensure their suitability in terms of size and colour.

▶ Note the dry brushstrokes around the projecting rocks and the turbulent water beyond. This area of water has a dull greenish tinge, created by using a mixture of cool yellow and blue and a touch of Raw Sienna.

Finished painting

The main object here was to capture the contrast between the fast-flowing water with its highlights and foam, and the dark foreground rocks, riverbanks and overhanging foliage. I also wanted to produce a wide variety of leaf colours in the background trees, yet keep the shapes vague and misty. This was achieved by building up layers of colour wet-in-wet, then overpainting wet-on-dry in places. The light area seen through the trees adds to the misty background.

The Birks of Aberfeldy 30 x 42 cm (12 x 16 ½ in)

Painting multiple arches

The structure of a bridge needs to be carefully studied before you can start painting it. It is best to draw the outline for the bridge and the reflections together, then paint them both at the same time.

Planning the painting

Having walked across this magnificent bridge at Roquebrun in southern France, I found a way to reach the riverbank to take some reference photographs. The multi-arched bridge reflecting in the still water looked even more impressive from the position I chose, and there was an excellent view of the town and mountains beyond to enhance the scene.

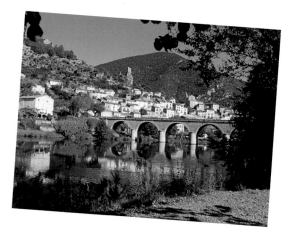

▲ This ground-level view gives an impressive sight of the bridge with the town of Roquebrun as a backdrop.

◀ An initial biro sketch established the general shape of the composition.

The only question was whether to paint the picture in portrait or landscape format and I plumped for the former to cut out the extraneous buildings on the left. I made a quick biro sketch to plan out the composition, then a colour sketch, which confirmed to me that the subject would make an interesting painting.

The balance of the composition worked quite well, but I decided that the overhanging foliage extended too low down and would have to be altered slightly when working on the finished painting. Also the distant mountain on the right was too strong in tone and needed to be paler.

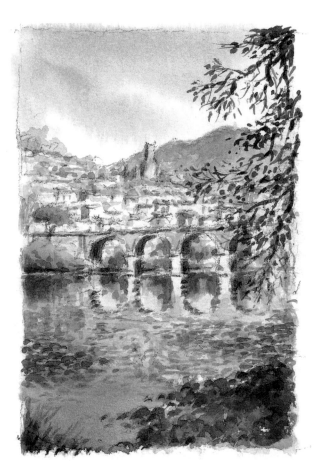

▲ A colour sketch based on my first biro drawing showed that the overhanging foliage was too intrusive.

Top technique

A simple way to work out the proportions of a complex bridge is to vary the classic technique of holding a pencil up at arm's length to check widths and heights. Instead, hold a strip of card in front of the scene, whether it is a real view or a photograph. Mark the gaps between arches on the top of the strip (and, if you turn the piece of card upright, you can mark the heights, too).

Transfer the details to your art paper. To do this, draw the horizon line and mark a suitable width for your bridge. From the centre of this drop a vertical line to the bottom of the paper and place a vanishing point near the bottom. Place the strip of card above this, parallel to the horizon line at a suitable distance so that lines from the vanishing points and the end marks on the card line up with the two bridge width marks. Draw guidelines from the vanishing point through the marks on the card to determine the gaps of the arches on the horizon line.

◀ Mark the spacing and heights of the arches of the bridge on a piece of card.

▲ Transfer the details from your card onto the art paper at the appropriate size you require.

◀ Take the cool blue river colour over the whole water area. Slightly darken the mix for the colour of the stone bridge and its reflection.

Paint the sky and river together with cool blue, taking the colour on the river from the bottom of the far bank downwards over the bridge reflection. Before this dries, add a touch of Burnt Sienna mixed with cool blue for the stone bridge colour. Paint reflections to blend into the still-damp blue of the water. Add a little warm blue and a touch of Burnt Sienna for shading and emphasis and add even more for the deep shadow areas beneath the arches of the bridge. More of the reflections of the dark curved areas under the arches shows in the water than appears above because the viewer is looking down slightly on the water.

▲ Darken the mix further for shading and even more for deep shadow under the arches of the bridge.

Other useful tips

☐ Simplifying clusters of buildings

A mass of distant buildings can be daunting both to draw and paint unless you simplify the process. Use shadows and highlights to suggest the shapes instead of drawing them meticulously. Where buildings overlap, the dark shadow on one will emphasize the shape of the other.

Draw guidelines from a suitably placed vanishing point to line up with the lines of the roofs so that they are all in correct perspective when viewed from below. With the light source from, say, above right, the shadow sides of the buildings will be on the left, so emphasize these together with the roofs.

Draw ragged lines with plenty of breaks – roofs will almost certainly sag slightly along the ridgeline. A few ticks can suggest window edges and recesses, with a fine line for the gutter. Remember, too, that buildings appear smaller as they recede into the distance.

▶ Use a soft pencil for light shading on roofs – darker for walls in shadow. These areas alone will suggest the general form of each building even without any detail.

▼ When painting a wall in shadow wait until the paint is nearly dry, then touch in a little darker paint at the apex. This will blend into the damp layer below, graduating the colour.

Paint overlapping trees or foliage first to avoid complications later. Paint the buildings in tones that match your pencil sketch. Start with a pale mixture of cool yellow and Raw Sienna. When dry, paint the roofs with a cool and warm red mix, with a little Burnt Sienna and warm blue added to dull the colour. Keep the roofs light in tone or they will come forward and dominate the painting. For a warm sunny effect, paint shadow areas with a warm blue and cool red mix, or cool blue and Burnt Sienna for a cooler look. Darken either mixture by adding warm blue and a touch of Burnt Sienna for really heavy shadows or for emphasis. Where shadows overlap, the paint can simply blend at these points.

Finished painting

The background mountain was painted with cool blue and yellow to look distant and the monument on the hill was positioned off centre.

The overhanging foliage was reduced and now looks less intrusive; this dark area of the painting is balanced by the strong colours and tones of the foreground.

Bridge at Roquebrun 33 x 23 cm (13 x 9 in)

Separating foliage from the background

Visiting a scene on different days can be rewarding as the background and foreground can look very different with a slight change in the weather. Separating nearer trees from a mountain beyond is important to establish depth.

Planning the painting

I made two visits to a loch on two days when the weather was completely different. On an overcast day the water was quite disturbed and the reflections indistinct. On a calm sunny day with little movement the reflections were very clear and almost a mirror image of the area above.

The unusual tree that I photographed on my first visit was a useful foreground feature and I decided to move it to the left in my sketch to balance the composition. A light patch on the distant water is useful to add a sense of distance. I was keen to capture the reflections of the trees and white lochside buildings with a few gentle ripples around the edges. I moved the headlands on the left closer to those on the right and included a few small rocks in the foreground for added interest in the painting.

There are usually quite a lot of moored boats in the loch, especially in summer. I decided to include two small ones for visual interest, wishing to retain emphasis on the reflected buildings and trees.

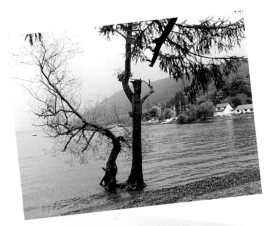

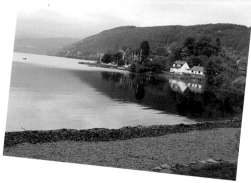

▲ Loch Tay photographed on a dull day and a fine day. The reflections are clearer on a calm surface with no breeze.

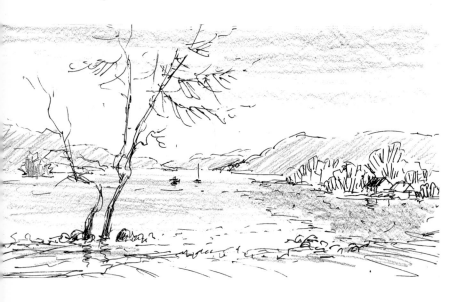

- Tree is repositioned to aid the composition.

- Headland moved to the right to condense the scene.

- Include light patch on the horizon.

- Sky colour is reflected in the water.

- Show ripples at the edges of the tree reflections.

- Rearrange rocks in the water and on shore.

Top technique

Sometimes your painting can produce a hard line between the top of a line of trees and the mountain in the background, especially if they are painted separately with strong colours. A simple way to avoid this is to first paint a common background colour over both the mountain area and the trees.

Blend further layers of colour wet-in-wet into the base colour to build up to the desired finish. In the early stages it is important to keep the colours pale. In any case the distant mountain needs to be a pale tone to appear far away, so it can be overpainted with cool blue-grey. A mid-distant mountain covered with foliage can be built up using the same colours to start with as the nearer tree line.

Be sure to keep the surface damp to start with as blending in colours wet-in-wet ensures the softness of the line between the mountain and the trees below. Once these early washes are in place it is a simply a matter of overpainting stronger colours for both the mountain and the tree line below. Ensure that you leave a crisp, not ragged, white unpainted edge to the buildings.

▲ Here, a common background colour –
a pale wash of cool yellow mixed with
Raw Sienna – was painted over both
the mountain area and the trees.

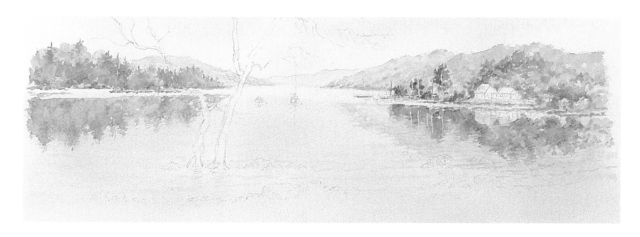

▲ Blend colours in wet-in-wet for a soft
edge between the mountain and the
tops of the trees below. When the
early washes are in place, overpaint
with stronger colour.

Other useful tips

☐ Creating mirror images on calm water

Usually it is best to paint reflections at the same time as the object above, but this is not always convenient for a complex subject. In this case the trees and reflections are painted separately.

Build up the colours in layers, starting with a pale wash of cool yellow, blending in cool blue in places. Overpaint while still damp, adding warm yellow and warm blue, with here and there a touch of warm red. This gives a varied selection of greens. Add darker colour and more detail as the paint dries. Use a roughly painted stronger line of colour to emphasize the banks, adding more warm blue and Raw Sienna to the mix.

Apply clean water over the loch below the trees. When this is almost dry, paint a base coat of cool yellow to mirror the shape above, leaving a small unpainted gap to separate the two areas. This gap, though not 'real', creates a visual distinction between the trees and the reflections. Build up soft reflections on the damp surface, using the same colours as for the trees, but with less detail.

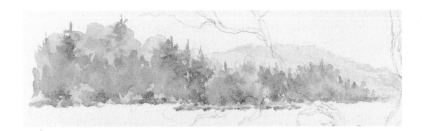

◄ The trees are built up in layers, blending in washes of cool colours, then overpainted with stronger, warmer colours with random touches for variety.

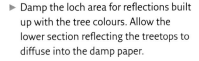

► Damp the loch area for reflections built up with the tree colours. Allow the lower section reflecting the treetops to diffuse into the damp paper.

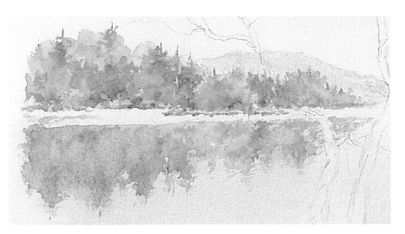

☐ Suggesting ripples on calm water

As ripples approach the shore the gaps between the rows increase. Leave breaks in the lines, which should meander gently. Use a pale blue-grey mixture that matches the colour used for the lake. Paint the edges of a dark reflection with short ragged horizontal lines that merge gently with the ripples on the loch in general. Apply the ripples with a small round brush or rigger.

▲ Use a pale blue-grey mixture of the colour used for the water to suggest ripples on a calm surface.

▶ This detail shows that the reflections of the rocks are lighter in tone than the rocks themselves. Many of the rocks and small stones on the shore were painted wet-in-wet with soft edges and others were painted wet-on-dry for a crisper look.

Finished painting

The large tree dominates the painting although the eye is still drawn to the white buildings and their reflections. The pale distant headlands look far away because of the cool colours used. The effect of aerial perspective is clearly seen – the nearer headlands are painted with increasingly stronger, warmer colours and appear much closer.

The foreground rocks are spaced randomly, but are positioned to keep the viewer's eye within the painting. Their rounded tops catch the light on one side, enhancing the pervading sense of light.

Loch Tay 27 x 43 cm (10½ x 17 in)

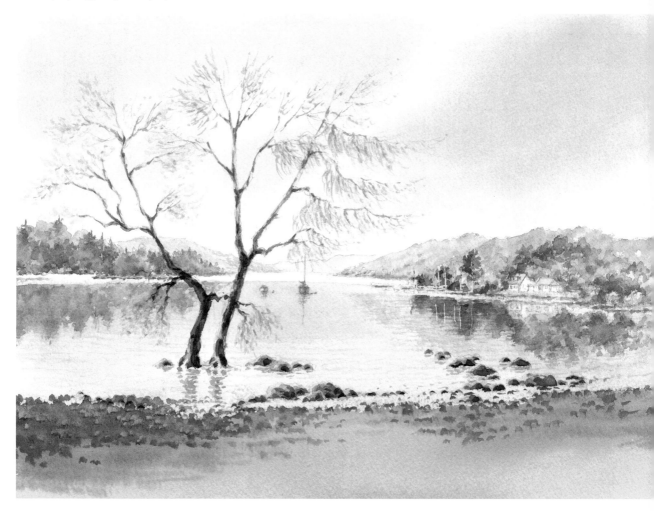

Suggesting morning mist

Emphasizing tonal variations can give a real impression of depth and is an ideal way to suggest the mist on a river. Many neutral colour variations are possible using a limited palette of only three primaries if they are mixed correctly.

Planning the painting

Early morning mist shrouded this river in Dorset, England, but the sun emerged from the gloom from time to time. I took a rather dull photograph when the mist had cleared a little, but relied on my memory to capture and paint the atmosphere of the misty morning.

I made a quick pencil sketch to work out the composition. The pleasant curve of the river and the adjoining path lead the eye to the distant moored sailing boats. The distant trees are hard to see in the photograph, but the mist gave them a dull neutral yellowish appearance that I hoped to capture in my painting.

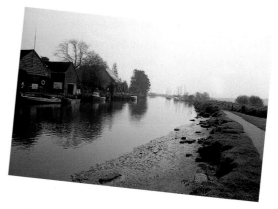

▲ A misty morning view of the river at Wareham in Dorset.

I decided to use the side of the bristles of a medium round brush for loose-edged distant foliage, which would establish a general soft appearance when painting the scene.

- Paint the sky and water together – the sky light to dark down to the horizon, then the river dark to light.

- Lift out a round shape in the sky for the sun, and a vertical streak on the water for the reflection, while still damp.

- Paint the trees and their reflections at the same time for a good colour match.

- Curve of the path leads the eye into the painting.

- Dark foreground grasses help to add depth.

Top technique

Many variations are possible using just three primaries, but the secret of mixing colours for a misty effect is to use one primary as a dominant colour, then add a tiny touch of the other two. For example, mix yellow with a tiny amount of red and blue. Experiment with more or less of each of the added colours and change one or both for warm or cool as required. Adding more of each of the other two primaries will result in a more neutral colour. If you add too much you will achieve only a muddy or dull grey colour.

An alternative method is to add two primaries – say red and yellow, to make orange – and then add a touch of the third primary – in this case blue – to neutralize the mixture.

▲ Mix a neutral colour by using one primary close to the colour you want, with just a touch of the other two added.

Finished painting

A neutralized yellow is ideal to portray misty scenes and in this painting a fairly dark mixture was used for a moody effect. The result is almost monochrome, which is the effect I wanted.

Note how the heavy vertical shading at the edges of the grassy banks makes their shape more evident. The moored boats are all pointing towards the rising sun, so the backs are in shadow as is the side of the building on the far bank.

Misty Morning 34 x 55 cm (13½ x 21½ in)

Painting falling water

Before you start to paint it is helpful to draw the clear outline of each area of falling water – the downward and onward progress of the different channels of water must look as feasible as in the real scene.

Planning the painting

It was well worth a walk through the woods to find this series of small waterfalls in Snowdonia in Wales. A small open area provided a number of possible viewpoints of the cascading water – this was a case where it paid to walk around and consider the subject from all angles rather than stopping at the first place that caught my eye. It is surprising how easy it is to lose an opportunity by immediately sketching the first scene that comes into view. I chose this spot as it enabled me to include both the narrow falls in the background and the more powerful one in the foreground.

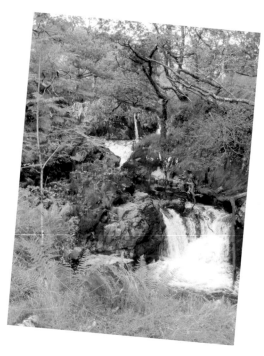

▲ This small waterfall had a series of falls of different sizes and made an interesting subject.

The only problem was that there was almost too much detail, with background rocks and foliage as well as foreground grasses and overhanging branches in abundance. My thought was to simplify the scene and highlight the main features. For once I had a reasonable amount of time, so I made a pencil sketch on location that included much of the detail that would help me when working on the finished painting back in the studio. I used a soft pencil and concentrated in particular on the rock shapes that surrounded the water on all sides.

◄ My pencil sketch brought out the busy background and overhanging foliage. Note the heavy shading with a soft pencil for the rock contours.

Top technique

Draw and paint dark rocky outcrops and banks to enclose and contrast with each area of water. The techniques and colours used for painting the water are virtually the same as for the fast-flowing water of a river except that falling water is generally much paler in tone. It is important to retain much unpainted paper to make the water stand out from the surroundings. When you paint moving water match the brushstrokes to the direction and shape of the flow.

Damp the area of water with clean water, then stroke in a pale mix of cool blue to emphasize the downward flow. Unlike a river, the downward fall of water is painted with smooth vertical brushstrokes, with just a little shading for these.

Where the cascade strikes the flatter water below there will be turbulence, which can be described with shorter curved strokes using a round brush. The colours can be a mixture of light and dark blues and pale grey-greens.

Usually, the water then flattens out briefly before moving forward over the next fall. These flatter areas of water often look dark and greenish because of the overhanging foliage, so make the colour mixes stronger.

Where the falls drop over rocky outcrops use dry-brush technique and a darker mixture of warm blue and Burnt Sienna. Apply the colour with short, brisk, curving downward strokes with a small hog's hair brush, leaving unpainted gaps in between to allow the surface of the paper to show through as sparkling highlights.

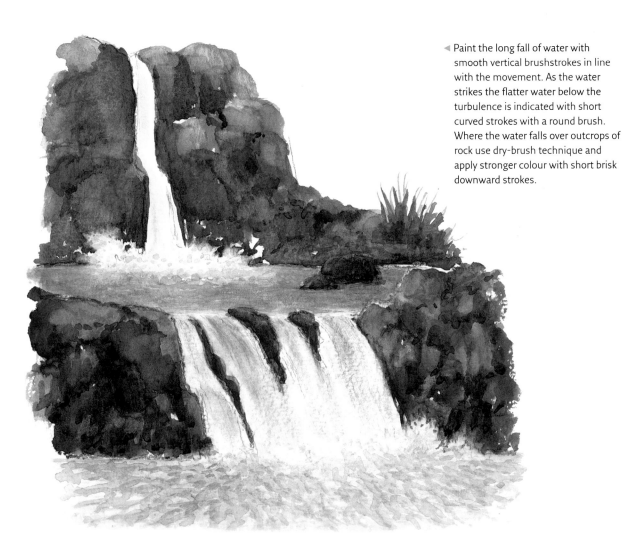

◀ Paint the long fall of water with smooth vertical brushstrokes in line with the movement. As the water strikes the flatter water below the turbulence is indicated with short curved strokes with a round brush. Where the water falls over outcrops of rock use dry-brush technique and apply stronger colour with short brisk downward strokes.

Other useful tips

Isolating moving water

The location of most waterfalls means that they have an abundance of rocks, trees and foliage around them. It is important to isolate the falling water from this 'busy' background to make it stand out. A sensible starting point is to sketch the outline of the areas of water and use this as the basis of the composition. Generally, the water is light in tone compared to the surroundings and emphasizing this in your painting will give the falling water greater impact. Placing the darker rocks alongside the water will also help.

◀ Sketch the outline of the areas of water and use this as the basis of the composition.

▶ A quick colour sketch can help you simplify the scene to highlight the individual areas of moving water and capture the direction of movement.

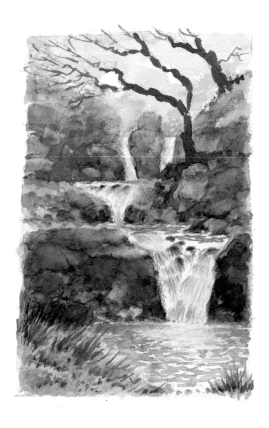

Emphasizing flat and rounded rocks

Individual rocks and clusters should not be painted as bland flat areas that have no form. The viewer needs to be shown their bulk and shape and the various facets of the surfaces.

Paint the rocks wet-in-wet, blending in suitable colours to bring out the tones. Use various mixtures of brown, grey-blue, grey-green as well as violet for the shaded areas. Match the direction of the brushstrokes with the slope, flatness or roundness of the rock shapes. Fine crevices will be in shadow, so use a fine brush to add these when the surface colour is dry. Avoid simply painting an outline around the edge of the rock shape and filling in the space between – use the shading on one rock to establish the shape of the lighter one next to it.

▼ A pencil sketch with a soft pencil can be useful. By using directional hatching you can indicate the various slopes and surface variations easily. When you paint the rocks, vary the tones to further enhance the realism.

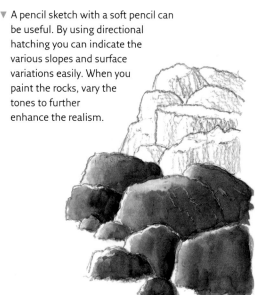

Finished painting

Reducing the surrounding material helps to highlight the cascading water, but the darker tones of the surrounding rocks and foliage also play their part. The overhanging tree branches help frame the subject and the small patch of light sky at the top of the painting provides an airy touch to the whole scene.

Snowdonia Waterfall 30 x 25 cm (15 x 10 in)

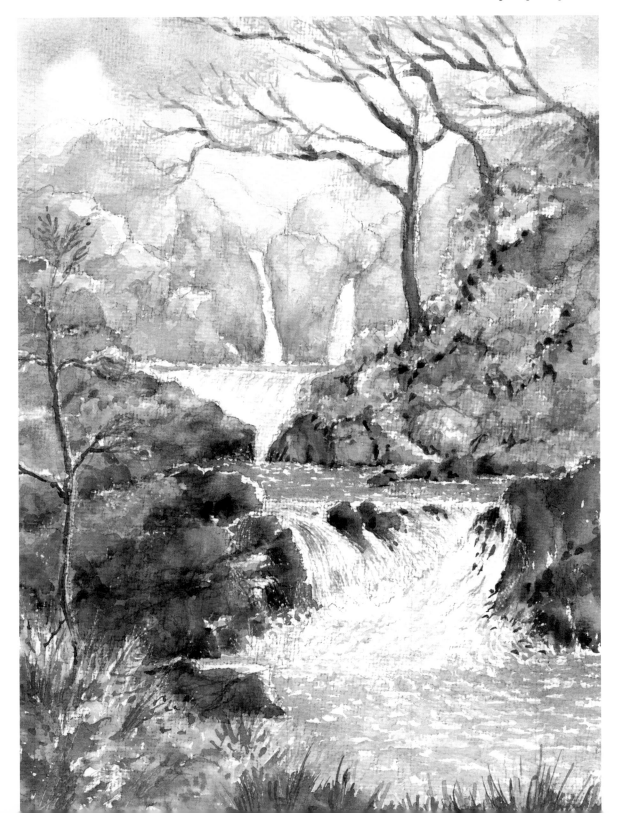

Lifting out colour

A subject such as a sunrise can often mean lifting out colour to enhance the effect. This needs to be part of the initial planning for your painting because the lifting out needs to be done at each stage of the painting process to ensure success.

Planning the painting

This windmill in southern England is a popular subject with local artists in the area, but it is located in quite a cramped position, although there is a very fine barn close by that could also be included in a painting. However, I decided to combine two photographs and to use artistic licence to 'move' the windmill into a more open setting. It is a good practice exercise for an artist to combine elements from various sources – integrating the windmill into another scene I photographed at a nearby river offered interesting possibilities. To paint the picture as a sunrise was a further challenge.

As usual, I made a pencil sketch to plan the composition. I decided to place the windmill in the mid distance, but later moved it even further back to enhance the atmosphere of the painting. I also brought the river in from the side to retain the flat appearance on the water.

▲ Two photographs – the river at Eling, and Bursledon windmill, both in Hampshire – provide features to combine in one painting.

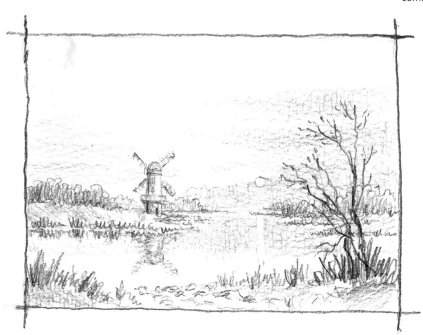

- The windmill is positioned left of centre on the far bank so that the reflections can be seen in the river below.

- The winding river has been given a more interesting shape and extended to disappear into the distance.

- The distant trees have been lowered for better balance in the composition.

- The large tree has been changed to a small bush, also for better balance.

Top technique

Damp the paper and paint the sky and water, working light to dark down to the horizon, and dark to light to the bottom. Use a light wash of cool yellow and Raw Sienna, with a little warm red. Just before this dries lift out the sun, its reflection on the water and a streak on the horizon using a 'thirsty' (barely damp) brush. When dry, damp the paper again. When the shine subsides, blend in strong mixes of cool red and blue for clouds and their reflections. Before it dries lift out the sun and other areas again, plus the side of the mill and its reflection. Use a cool red and warm blue mix plus a little Raw Sienna to tone down brightness to add detail wet-on-dry.

▶ Paint an initial light wash and blend in more colour here and there. While still damp lift out areas using a round brush for the sun and a flat brush for a thin streak on the horizon.

▶ Blend in stronger colour mixes, pulling the brushstrokes in from each side with a large brush. Before dry, lift out the required lighter areas for a second time.

Finished painting

I used lightweight, smooth-surfaced paper to achieve the subtle washes of blue-violet. I left a light area in the banks of cloud to attract the eye to the windmill and used stronger colours in the foreground to add to the feeling of depth.

The Old Mill 36 x 55 cm (14 x 21½ in)

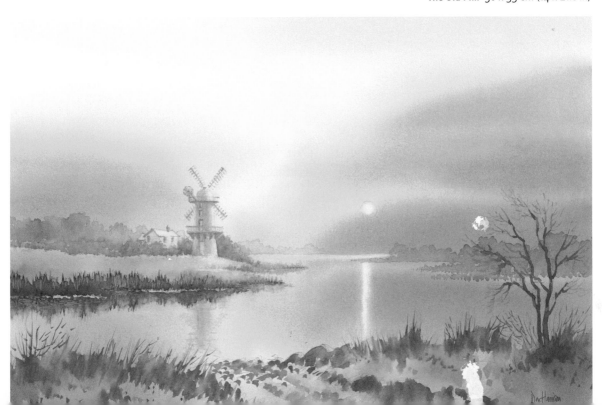

Further information

There is a wealth of further information available for artists, particularly if you have access to the internet. Listed below are just some of the organizations or resources that you might find useful to help you to develop your painting.

Art Magazines

The Artist, Caxton House, 63/65 High Street, Tenterden, Kent TN30 6BD;
tel: 01580 763673
www.theartistmagazine.co.uk

Artists & Illustrators, The Fitzpatrick Building, 188-194 York Way, London N7 9QR;
tel: 020 7700 8500

International Artist, P. O. Box 4316, Braintree, Essex CM7 4QZ; tel: 01371 811345
www.artinthemaking.com

Leisure Painter, Caxton House, 63/65 High Street, Tenterden, Kent TN30 6BD;
tel: 01580 763315
www.leisurepainter.co.uk

Art Materials

Daler-Rowney Ltd, Bracknell, Berkshire RG12 8ST; tel: 01344 424621
www.daler-rowney.com

Jackson's Art Supplies, 1 Farleigh Place, London N16 7SX; tel: 020 7254 0077
www.jacksonsart.co.uk

T. N. Lawrence & Son Ltd, 208 Portland Road, Hove, West Sussex BN3 5QT;
tel: 0845 644 3232 or 01273 260260
www.lawrence.co.uk

Winsor & Newton, Whitefriars Avenue, Wealdstone, Harrow, Middlesex HA3 5RH;
tel: 020 8427 4343
www.winsornewton.com

Art Shows

Artists & Illustrators Exhibition, The Fitzpatrick Building, 188-194 York Way, London N7 9QR; tel: 020 7700 8500 (for information and venue details)

Patchings Art, Craft & Design Festival, Patchings Art Centre, Patchings Farm, Oxton Road, Calverton, Nottinghamshire NG14 6NU; tel: 0115 965 3479
www.patchingsartcentre.co.uk

Affordable Art Fair, The Affordable Art Fair Ltd, Unit 3 Heathmans Road, London SW6 4TJ;
tel: 020 7371 8787

Art Societies

Federation of British Artists (including Royal Society of Painters in Water Colours), Mall Galleries, 17 Carlton House Terrace, London SW1Y 5BD; tel: 020 7930 6844
www.mallgalleries.org.uk

Royal Watercolour Society, Bankside Gallery, 48 Hopton Street, London SE1 9JH;
tel: 020 7928 7521
www.banksidegallery.com

Society for All Artists (SAA), P. O. Box 50, Newark, Nottinghamshire NG23 5GY;
tel: 01949 844050
www.saa.co.uk

Bookclubs for Artists

Artists' Choice, P. O. Box 3, Huntingdon, Cambridgeshire PE28 0QX;
tel: 01832 710201
www.artists-choice.co.uk

Painting for Pleasure, Brunel House, Newton Abbot, Devon TQ12 4BR;
tel: 0870 44221223

Internet Resources

Art Museum Network: the official website of the world's leading art museums
www.amn.org

Artcourses: an easy way to find part-time classes, workshops and painting holidays
www.artcourses.co.uk

The Arts Guild: on-line bookclub devoted to books on the art world
www.artsguild.co.uk

British Arts: useful resource to help you to find information about all art-related matters
www.britisharts.co.uk

British Library Net: comprehensive A-Z resource including 24-hour virtual museum/gallery
www.britishlibrary.net/museums.html

Don Harrison: the author's website, with details of his books, painting videos, art materials and a gallery of his paintings
www.watchingpaintdry.co.uk

Galleryonthenet: provides member artists with gallery space on the internet
www.galleryonthenet.org.uk

Harrison Gallery: on-line gallery, including watercolours by Don Harrison
www.harrisongallery.com

Jackson's Art Supplies: on-line store and mail order company for art materials
www.jacksonsart.com

Open College of the Arts: an open-access college, offering home-study courses to students worldwide
www.oca-uk.com

Painters Online: interactive art club run by The Artist's Publishing Company
www.painters-online.com

WWW Virtual Library: extensive information on galleries worldwide
www.comlab.ox.ac.uk/archive/other/museums/galleries.html

Videos

APV Films, 6 Alexandra Square, Chipping Norton, Oxfordshire OX7 5HL; tel: 01608 641798
www.apvfilms.com

Teaching Art, P. O. Box 50, Newark, Nottinghamshire NG23 5GY; tel: 01949 844050
www.teachingart.com

Further reading

If you have enjoyed this book, why not have a look at other art instruction titles from Collins?

The Artist magazine, *The Artist's Watercolour Problem Solver*
Artists' Rescue Tactics
Bellamy, David, *Coastal Landscapes*
Gair, Angela, *Collins Artist's Manual*
Harrison, Don, *The Duffer's Guide to Watercolour Landscapes*
Watercolour Troubleshooter
Hodge, Susie, *How to Paint Like the Impressionists*
Jennings, Simon, *Collins Art Class*
Collins Artist's Colour Manual
Lidzey, John, *Watercolour in Close-up*
Shepherd, David, *Painting with David Shepherd*
Simmonds, Jackie, *Watercolour Innovations*
Soan, Hazel, *African Watercolours*
Stevens, Margaret, *The Art of Botanical Painting*
Trevena, Shirley, *Taking Risks with Watercolour*
Whitton, Judi, *Loosen up your Watercolours*

For further information about Collins books visit our website:
www.collins.co.uk

Index

Page numbers in *italic* refer to captions

aerial perspective *34*, 38, 85
arches *53*, 71, *71*, 78, 79, *79*, 81

background 6, 38, *38*, 82, 90, *90*
 trees 74, *74*, 76, *76*, 77, 82-3, *82-3*
backlit figures 61, *61*
back-runs 29, 72
beaches 26, *27*
boats
 figures on 14, *14*, 17, *17*
 moored 10, *10*, 12-13, *12-13*, 24, *24*, 27, 28, *31*, 82, 87
 reflections 12, *16*, 30, *30*
 shapes 16, *16*, 30, *30*
bridges 70-1, *70-1*, 73, *73*, 78-9, *78-9*, 81
brushes, chamfering 68, *68*
buildings
 circular 52-5, *52-5*
 coastal scenes 14, 17, 18, *18*, 21, *21*, 56-7, *56-7*
 landscapes 34, *34*, 35, 36, 38-9, *38*, 40-1, *40-1*, 46-9, *46-9*, 80, *80*, 85, 92-3
 perspective 46, 47, *47*, 53, *53*, 59, 62, *62*, 80, *80*
 shadows 50-1, *50-1*, 53, 62, *62*, 63
 townscapes *44-5*, 50-5, *50-5*, 58-63, *58-63*, 80, *80*

cast shadows 50-1, *50-1*, 61, *61*, 62, *62*, 63
chamfering brushes 68, *68*
circular buildings 52-5, *52-5*
clouds 13, *23*, 26, *26*, 56-7, *56-7*, 72, 72
coastal scenes 8-31, *8-31*, 56-7, *56-7*
 see also specific topics (e.g., waves)
cobbles 54, *54*
colours 6-7
 greys 57
 neutral mixes *23*, 23, 87, *87*
columns *50*, 51, *51*, 52, 53
cool colours 6-7
country views *see* landscapes

ellipses 53, *53*
eye level 47, *62*

farms 40-1, *40-1*
fences 48, *48*
fields 40-1, *40-1*, 68, *68*
figures
 for architectural scale 50, *50*, 51, 55
 in boats 14, *14*, 17, *17*
 in street scenes 58, 59, 60-1, *60-1*, 63
fir trees 48, *48*
foam and spray 20, *20*, *74*, 75, *75*
foliage *38*, 67, *67*, 76, *76*, 78, *78*, 80-1, 86, 88-90
 see also trees
foreground 6, 26, 27, 39, 40-1, *40-1*, 82, 85

gates *46*, 49, *49*
grapes 36-9, *36-9*
grasses 68, *68*
greys 57

hake brushes 68, *68*
headlands 18, *18*, 21, *21*, 24-5, *24-5*, 27, *27*
horizon line 47, *62*

lakes and lochs 82-5, *82-5*
landscapes 32-43, *32-43*, 46-9, *46-9*, 64-93, *64-93*
 see also specific topics (e.g., mountains)
leading viewer's eye 46, *46*, 49, 57, 58-9, *70*
lifting out 20, *20*, 26, *86*, 92-3, *92-3*
light *see* shadows; sunlight

masking fluid and tape 6, 22, *22*, 23, 43
masts and rigging 12-13, *12-13*
mist 86-7, *86-7*
Mont St Michel 56-7, *56-7*
mountains 34-5, *34-5*, 82-3, *82-3*
mud banks 10-13, *10-13*, 75

neutral colour mixes *23*, 23, 87, *87*

ovals 53, *53*

paper 6, 11
 see also unpainted paper
Parthenon 50-1, *50-1*
perspective and vanishing points
 aerial perspective *34*, 38, 85
 bends in streets 59, 62, *62*
 bridges and arches 71, *71*, 79, *79*
 buildings 46, 47, *47*, 53, *53*, 80, *80*
 cobbled surfaces 54, *54*
 gates 49
 moored boats 12
 one-point perspective 59
 waves 20, *20*
primary colours 6-7, *7*
puddles 59
putty-rubber boat shapes 16, *16*

rain 58-9, *58-9*
reflections
 boats 12, *16*, 30, *30*
 bridges 70, 71, *71*, *73*, 78, 79
 headlands 24-5, *24-5*
 rocks *31*, 85, *85*
 trees 82, 84, *84*, 86
 wet townscapes 58-9, *58-9*
 windmill 92-3, *92-3*
rigging and masts 12-13, *12-13*
ripples 14-15, *14-15*, 30, 71, 84, *84*
riverbanks 66, *66*, 68, *68*, 75, 87
 mud banks 10-13, *10-13*, 75
rivers 66-81, *66-81*, 86-93, *86-93*
rocks
 fields 41, *41*
 headlands 18, *18*, 21, *21*, 24-5, *24-5*, 27, 27
 reflections *31*, 85, *85*
 rivers and lakes *74*, 75, 77, 85, *85*
 seaside 28, *28*, 31, *31*
 waterfalls 88-91, *88-91*
roofs and tiles 38, *38*, 49, 55, 72, *72*, 80, *80*

sand 26, *26*
seascapes *see* coastal scenes
seaweed 26, *26*, 27, *27*
shadows
 arches 53, 71, 79, *79*

buildings 50-1, *50-1*, 53, 62, *62*, 63, 80, *80*
figures 61, *61*
snow scenes 34, 35, *35*, 43, *43*
waves 19, *19*, 23, *23*
sky
 clouds 13, *23*, 26, *26*, 56-7, *56-7*, 72, 72
 coastal scenes 22, 23, 26, 28-9, *28-9*, 56-7, *56-7*
 landscapes 39, 72, 72
snow 34-5, *34-5*, 42-3, *42-3*
spray and foam 20, *20*, *74*, 75, *75*
squaring up 53
street scenes and townscapes *44-5*, 50-5, *50-5*, 58-63, *58-63*
stubble 41, *41*
sunlight
 misty 86-7, *86-7*
 strong 50-1, *50-1*
 sunrise 92-3, *92-3*
 sunset 28-9, *28-9*, 31, *31*

texture 40-1, *40-1*
three-dimensional quality, conveying 36, 37, *37*, 52, 53, 55
tiles and roofs 38, *38*, 49, 55, 72, *72*, 80, *80*
tonal sketches 12, *14*, 25, *25*, 90
townscapes *44-5*, 50-5, *50-5*, 58-63, *58-63*
trees
 background 74, *74*, 76, *76*, 77, 82-3, *82-3*
 firs 48, *48*
 focal point 82, 85, *85*
 framing view 40, *40*, *41*, 42, *42*, 46, 76, 91
 reflections 82, 84, *84*, 86
 summer 66-7, *66-7*, 69, *69*
 see also foliage

unpainted paper
 highlights on fruit 37, *37*
 snow 34, 35, 42, 43
 spray and foam 20, *20*, *74*, 75, *75*
 waterfalls 89
 wave crests 18, *18*, 19, 22

vanishing points *see* perspective and vanishing points
vineyards 36-9, *36-9*

warm colours 6-7
water
 fast-flowing 74-5, *74-5*, 77, *77*
 ripples 14-15, *14-15*, 30, 71, 84, *84*
 rivers 66-81, *66-81*, 86-93, *86-93*
 spray and foam 20, *20*, *74*, 75, *75*
 turbulence 75, *75*, 89, *89*
 waterfalls 88-91, *88-91*
 waves 18-21, *18-21*, 22-3, *22-3*
 see also reflections
weather
 mist 86-7, *86-7*
 rain 58-9, *58-9*
 snow 34-5, *34-5*, 42-3, *42-3*
wet-in-wet technique (wet blending) 11, *11*, 28, 29, 29, 72, 72
wet-on-dry *15*, 29, 30, 76
windmill 92-3, *92-3*